靜觀其變 英國現代雕塑展
FIELD DAY Sculpture from Britain

主辦單位：台北市立美術館　英國文化協會
Organised by the Taipei Fine Arts Museum and The British Council

英國文化協會

展期：2001年4月7日至6月24日
7 April - 24 June 2001

目錄 CONTENTS

序言

我們很高興向各位呈獻這次盛大舉行的英國現代雕塑展,這項展覽是台北市立美術館與英國文化協會通力合作的成果。展覽作品從 1960 年自從倫敦首度成為世界首屈一指的都會開始,到九〇年代英國青年藝術家,以混合著創新、華麗、與直率的特有風格成為國際注意焦點的 2001 年止。令人興奮的是,我們首次有此展覽機會,讓台灣觀眾觀賞英國藝術在這特別時期的創造精神,並希望這次展覽能夠帶給各位一些啟發和樂趣。

在所有英國藝術的形式中,雕塑在二十世紀被認為是最具有創意且令人驚奇的。四〇年代末期,亨利‧摩爾就扭轉了一般對人體的看法,他將人體視成是抒情的景觀,使他在國際間倍享聲譽。而其觀點也激發了後來的雕塑家打破窠臼,尋找自已的語彙,發出自己的聲音。這也是為什麼我們將這次展覽英文名稱定名為「FIELD DAY」的部份原因:一是代表不只侷限於傳統雕塑上的平面及空間二種面向,同時也代表雕塑家在這時期勇於挑戰的創作盛況與歡愉。

以六〇年代早期安東尼‧卡羅和菲利普‧金的彩色雕塑為起點,這項展覽從一個激進的標註開始:雕塑並非只是關注於如何重塑已知世界的物體與形象,也不再為台座、基座等,那些通常用來呈現作品的裝置費心,它是直接大膽地被放在地上,傳達了雕塑自由和趣味的新感受,靈巧地呈現作品內在的本質。而接下來幾個世代的英國雕塑家,也以這種創新的精神出發,實驗與創造各種新的雕塑形式:如紀伯與喬治嘲諷的自畫像式的錄影帶;貝瑞‧佛拉納格調皮地在地板上堆積條狀填充物;湯尼‧克雷格用撿拾的塑膠廢料佈置造景;麥可‧克雷格-馬丁用黑色膠帶直接貼在牆上描繪出各種象徵記號;理查‧龍以自己的足跡重塑地景,成功地創造了另一種語彙與文本;蒙娜‧哈同用內視鏡拍攝自己的身體內部。而本世紀英國雕塑發展背後動力之一,就是在作品中採用並融合新的媒材與科技。在此,我們很高興這次展覽能匯集各種令人印象深刻的作品,讓台灣民眾自己發現英國雕塑家作品中豐富的媒材與表現方式。尤其值得一提的是,以裝置藝術聞名的雕塑家理查‧威爾森將他著名的作品20:50空運來台北重新裝置,就是為了台北市立美術館這次展覽所做的特別創作。

這項展覽的策劃與作品選件,是由台北市立美術館的張芳薇與英國文化協會視覺藝術部的展覽策劃員理查‧瑞禮(Richard Riley),加上弗德列克‧多立弗(Frédérique Dolivet)協助共同完成。我們十分感謝他們辛勤的工作成就了這項展覽。如同以往,對藝術家本人以及與他們所屬的畫廊和經紀人,我們都十分感激他們熱情回應我們的參展邀請。對那些慷慨出借作品參展的人,特別由衷感謝。同時在此還要答謝這次展覽專輯文章的作者:英國「泰德美術館利物浦分館」前館長,目前是「利物浦雙年展」主席的路易斯‧畢葛(Lewis Biggs),他對現代英國雕塑的知識無人能出其右,還有張芳薇,以台灣的角度對英國雕塑做了具有洞見的觀察。最後,對許多還來不及提到名字的人,我要一併感謝他們支持這項展覽:

馬可士‧亞歷山大(Marcus Alexander),戴娜‧安德魯(Dana Andrew),易安‧巴克爾(Ian Barker),亞歷山卓‧布萊德雷(Alexandra Bradley),朱兒‧布利齊(Jules Breeze),理查‧卡爾福克羅西(Richard Calvocoressi),小作芳美(Yoshimi Chinzei),凱撒林‧克萊門(Catherine Clement),沙地‧柯爾(Sadie Coles),東尼‧康那爾(Tony Connor),派翠克‧康寧漢(Patrick Cunningham),維若尼卡‧戴賓(Veronique Dabin),克里斯頓‧杜恩(Kirsten Dunne),伊哲夫(Geoff Evans),史都華‧伊凡斯(Stuart Evans),蘇珊娜‧葛里福斯(Susanna Greeves),喬‧加特雷吉(Jo Gutteridge),克里斯‧漢茲(Chris Hands),索利‧韓森(Siri Hansen),克雷格‧韓德森(Craig Henderson),傑其‧休曼(Jackie Heuman),朱利安‧哈吉斯(Julian Hodges),葛斯‧休(Gareth Hughes),漢娜‧杭特(Hannah Hunt),安德魯‧伊格那斯基(Andrew Ignarski),是枝 開(Hiraku Kore-eda),李皓儒(Tomas Li),林曼麗(Munlee Lin),蘇珊‧梅(Susan May),凱撒琳‧馬歇爾(Catherine Marshall),凱文‧莫理斯(Gavin Morris),山第‧奈倫(Sandy Nairne),理查‧那許漢(Richard Nesham),克萊夫‧菲利波特(Clive Phillpot),約翰‧瑞迪(John Riddy),貝瑞特‧羅吉斯(Brett Rogers),雷恩‧羅德吉斯 (Ryan Rogers),珍尼絲‧史雷德(Janice Slater),馬克‧杜特(Marc Tutt),克蕾兒‧凡‧羅南(Claire van Loenen),安那‧維斯康瑟羅(Ana Vasconcelos),約翰森‧凡那(Jonathan Viner),克拉麗‧華勒斯(Clarrie Wallis),倪韋伯(Neil Webb),路易絲‧萊特(Louise Wright)。

黃才郎
台北市立美術館 館長

安德利雅‧羅斯
英國文化協會 視覺藝術部 主任

PREFACE

We are delighted to present this major exhibition of British sculpture, the result of a fruitful collaboration between the Taipei Fine Arts Museum and the British Council. The exhibition begins with work from the l960s - the period when London first became one of the hip capitals of the world - and ends in 2001, after a decade in which young British artists have been the focus of international attention, renowned for a particular blend of invention, panache and cheek. We are extremely pleased to be able to provide a first opportunity for audiences in Taiwan to see something of the spirit and invention that has characterised British art during this exceptional period, and hope that it will prove both enlightening and entertaining.

Of all the art forms in Britain, sculpture has been commonly regarded as the most surprising and innovative during the 20th century. The international reputation of Henry Moore in the late 1940s, based on his wholesale re-invention of the human body as a lyrical landscape, has encouraged the generations of sculptors that have followed him to break the rules, and to find each for himself the language necessary to develop an individual voice. This is in part why we have called the exhibition 'Field Day': an expression that suggests not only the formal planes and spatial dimensions with which sculptors have traditionally grappled, but the exuberance and sense of celebration with which they have undertaken the task.

Beginning with the coloured sculptures of Anthony Caro and Phillip King in the early l960s, the exhibition opens on a radical note: sculpture that sings and appears not at all concerned about whether it resembles the objects and images of the known world. Nor is it bothered with the usual presentational devices such as plinths or pedestals: it sits bold and bright on the floor, a herald of something new in sculpture - a sense of freedom and fun that allows wit to operate at the heart of the work, almost as if it were an invisible ingredient. Successive generations of British sculptors have taken their cue from this desire to experiment and create new forms: Gilbert and George with their wry video self-portraits; Barry Flanagan placing a heap of slyly placed bolsters on the floor; Tony Cragg, who lays out a landscape using found pieces of plastic rubbish; Michael Craig-Martin drawing global symbols in tape directly onto the wall; Richard Long re-inventing the landscape by walking across it and re-creating its sonority in language and text; Mona Hatoum inserting a camera into her own body and filming its passages. The ability to adapt and incorporate new materials and technologies into sculpture as they come along has been one of the motivating forces behind the development of British sculpture this century, and we are pleased that this exhibition is able to marshal such an impressive range of exhibits, permitting the Taiwanese public to explore for itself the breadth of media and expression with which British sculptors have

been working. We are particularly delighted that the sculptor Richard Wilson, celebrated for creating unforgettable installations such as *20:50* has been able to travel to Taipei to make a new installation specifically for this exhibition, a new commission from the Taipei Fine Arts Museum.

The exhibition has been selected and organised by Fang-Wei Chang, Curator of the Taipei Fine Arts Museum, and Richard Riley, Exhibition Curator in the British Council's Visual Arts Department, London, with the assistance of Frédérique Dolivet. We are grateful to them for their hard work and diligence in bringing it to fruition. We are, as ever, enormously indebted to the artists themselves, and to their galleries and agents, who have responded with enthusiasm to our invitation to take part in the exhibition. We should like to thank most warmly the lenders to the exhibition, whose generosity in parting with their works is greatly appreciated. Our thanks also go to all those who have helped us locate and prepare the works for exhibition, in particular to Diana Eccles, Collections Manager of the British Council Collection, and Jill Constantine, Assistant Curator of the Arts Council Collection. Our thanks go as well to the authors of the catalogue: to Lewis Biggs, until recently Director of Tate Liverpool and now Director of the Liverpool Biennial, whose knowledge of British sculpture of this period is second to none, and to Fang-Wei Chang for her insight into British sculpture from a Taiwanese perspective. Finally, we acknowledge the support given by a large number of people in realising this exhibition, and in addition to those listed above, offer our warmest thanks to the following:

Marcus Alexander, Dana Andrew, Ian Barker, Alexandra Bradley, Jules Breeze, Richard Calvocoressi, Yoshimi Chinzei, Catherine Clement, Sadie Coles, Tony Connor, Patrick Cunningham, Véronique Dabin, Kirsten Dunne, Stuart Evans, Susanna Greeves, Jo Gutteridge, Chris Hands, Siri Hansen, Craig Henderson, Jackie Heuman, Julian Hodges, Gareth Hughes, Hannah Hunt, Andrew Ignarski, Hiraku Kore-eda, Tomas Li, Munlee Lin, Susan May, Catherine Marshall, Gavin Morris, Sandy Nairne, Richard Nesham, Clive Phillpot, John Riddy, Brett Rogers, Ryan Rodgers, Janice Slater, Marc Tutt, Claire van Loenen, Ana Vasconcelos, Jonathan Viner, Clarrie Wallis, Neil Webb, Louise Wright

Tsai-Lang Huang
Director
Taipei Fine Arts Museum

Andrea Rose
Director of Visual Arts
The British Council

靜觀其變　英國現代雕塑展
FLELD DAY Sculpture from Britain

安東尼・卡羅	Anthony CARO
麥特・克里修	Mat COLLISHAW
湯尼・克雷格	Tony CRAGG
麥可・克雷格－馬丁	Michael CRAIG-MARTIN
理查・迪肯	Richard DEACON
貝瑞・佛拉納格	Barry FLANAGAN
安雅・葛拉契歐	Anyá GALLACCIO
紀伯與喬治	GILBERT and GEORGE
道格拉斯・葛登	Douglas GORDON
安東尼・貢利	Antony GORMLEY
席奧蓉・哈帕思卡	Siobhán HAPASKA
蒙娜・哈同	Mona HATOUM
戴彌恩・賀斯特	Damien HIRST
安尼許・克普爾	Anish KAPOOR
菲利普・金	Phillip KING
麥可・蘭迪	Michael LANDY
理查・龍	Richard LONG
莎拉・陸卡斯	Sarah LUCAS
愛德華・包羅契	Eduardo PAOLOZZI
理查・溫特渥斯	Richard WENTWORTH
瑞秋・懷特雷	Rachel WHITEREAD
理查・威爾森	Richard WILSON
比爾・伍德卓	Bill WOODROW

「打破框架」：1960-2001 英國雕塑導覽

路易斯・畢葛

註：「FIELD DAY」（演習日，為本展英文展名），是和平時期軍事活動的用語，代表野地訓練，而不是在軍營裡練習。這個慣用語，引申地說，也代表著戰爭時輕易取得的勝利，就如同演習一般。另外這個詞，也意味著歡愉或慶祝：例如小孩在遊樂場，有時玩的稍微過了頭，就可以說他們「having a field day」- 好好的玩了一整天。而「Square Bashing」，則是一句俚語，指的是在軍營裡從事軍事演習，但是在這裡，指的則是兩種傳統間的不相容。一是英國藝術的傳統，另一則是形式主義與自馬勒維奇（Kasimir Malevich）、蒙德利安（Piet Mondrian）等人以來抽象藝術的傳統。

自二十世紀中葉以來，英國雕塑就以形式的創新廣受到國際讚揚，包括挪用攝影、錄影、裝置藝術和表演等媒體形式。（就目前英國而言，「雕塑」這個詞在用法上，可泛指繪畫以外所有的視覺藝術。）在這項展覽中，雕塑形式上呈現的陌生感與多樣化，可能會是吸引台灣觀眾注意的原因。當我們面對生疏的事物時，通常我們經驗到的總是「形式」－事物的外形。我們總是以為可以簡單地經由對形式的複製，去欣賞異國的事物。而通常我們所期望的，就只是滿足於一種異國情趣的外在形式。不過可以想見的是，這其中的內涵也常因而流失。

但是我相信英國文化，包括這個展覽中所呈現的浮光掠影，最主要的還是以內容為主，而形式是為了產生內容的第二層考慮。因為對英國人而言，藝術應該是「說」些什麼，或者是「有關」某些事情的想法。再者，比起視覺語言，口語和書寫在英國文化中常具較大的力量，就某種程度來說，視覺藝術也受到敘事或修辭機制的引影響，包括幽默（特別是俏皮話）種種語言行為的影響。

在這篇為台灣觀眾所寫的導覽中，我將提供藝術品生產時空廣闊的文化脈絡，建議如何捕捉作品形式背後的內涵。雖然，這次展覽在取材選件上比較偏重近期的作品。不過我考慮平等地強調四十年中的各個時期。

六十年代

在搖擺舞曲盛行的六〇年代，英國是個洋溢著青春活力的地方。第二次世界大戰（1939－1945）之後，戰事所引發的生活消費與其他的限制也隨之消退。便宜的汽車及空中交通，讓更多人為了休閒而旅行。歐洲人來到英國尋找「美國」，美國人前往英國探訪「歐洲」。英國成了文化的十字路口。當詩人艾倫・金斯柏格（Allen Ginsberg）在六〇年代中訪問利物浦港的時候，他宣稱利物浦是「宇宙意識的中心」。

英國藝術在六〇年代生成的條件，奠基於五〇年代一群在紐約工作的藝術家，那時紐約是世界最重要的藝術市場。雖然許多英國的藝術家與批評家認為，英國的普普藝術與抒情抽象和美國有同等重要的地位，但是讓這些風格逐漸普行的論戰卻發生在美國。相對的，六〇年代在英國藝壇活躍的寫實主義風格，並沒有受到國際注意。

包羅契的歐洲版普普藝術，與傳統藝術家的工藝銜接，隱含著古典文學及悲劇氣質。其中有許多是在思考科技對傳統價值的衝擊。相反的，美國式的普普藝術，以愉悅的姿態重新發現科技的進展。作品隱藏的意義與時代氛圍緊密結合，透露出享樂主義式的訊息。如果這項展覽中，能有空間展出六〇年代以來，布魯斯・雷西（Bruce Lacey）、艾倫・瓊斯（Allen Jones）、或喬治、福拉德（George Fullard）等人著重外型輪廓的雕塑，這些作品將可提供包羅契雕塑的相對脈絡。而這些人的作品強調劇場特質，比起過去更富色彩，與如今我們持續對話的未來主義更有幽默與嘲諷的表現。而包羅契本人並不希望被視為一位超現實主義者或普普藝術家，他自認是位寫實主義者。

安東尼・卡羅一向承認作品受到紐約抒情抽象畫家的影響，還有形式主義理論家克雷蒙・格林伯格（Clement Greenberg）的影響。如果不交待上述這段關係，將難以明瞭卡羅作品背後的動力。卡羅雕塑的動力來自其人本主義者的關注，及他對作品的表情和姿態的興趣。然而，這些表情與姿態的意義並不明確－沒有像包羅契作品一般的計劃感－但這些雕塑，或許可經由音樂（卡羅本身最喜愛的類比）來瞭解。因為音樂不需要明顯的內容就可感動人心，音樂所喚起的情感就是它的內容。像是卡羅的「雕塑之七」，在他第一次訪問紐約後的一年間完成，是美國對他的創作影響最大的時候：他使用簡單強烈的顏色，大膽

強調簡樸的結構。但是在二年後的作品「五月」則完全不同，反而帶有英國特有的精緻線條與色彩，作品名稱也富詩意。

六○年代英國的繁榮，讓民眾可以拋棄許多保存經年的東西，改用技術發展後出現的新材料及成品。像是色彩明亮的塑膠容器或塑膠傢俱，就取代了陶瓷和木材。尤其是塑膠材質可供發揮的潛力，對許多雕塑者極具吸引力，像是將玻璃纖維結合樹脂的作法就是其中之一。菲利普·金就曾一度擁抱新材質及其在色彩表現的潛力。以銅為例，銅是一種非常昂貴的材料，貴得會讓一個購買者想知道所買到的到底是不是銅。但塑膠價值不高，所以可被接受成為表現色彩張力的素材，而不致於減損材質的價值感。而金就像卡羅一樣，在強調外型輪廓的雕塑之後，投入了抽象藝術。在當時（或現在也一樣），「抽象」被認為是可脫離「主題」的限制。而事實上這種想法，只是由一個主題移到另一個主題。在此前題下，主題即是一場對話，以形狀與顏色的隱喻來表達一個詩性的主題。「玫瑰花苞」與「漣漪」就具有一種情感張力，因為物體本身就已超越了它們詩意的源始。

我在前文曾提到詩人艾倫·金斯柏格，因為在六○年代，各種藝術形式的混合成為主要關鍵：爵士樂手，節奏作曲家，詩人和現代藝術家互相交流（兩位披頭四的成員就受過現代藝術的訓練）。在這個脈絡下，克雷蒙·格林伯格，從形式主義的觀點宣揚藝術實踐的自主性與純粹就顯得十分反潮流。因為六○年代的英國，正值學生反叛的年代，就像其他地方一樣，學生要求進一步參與教育改革。整個社會環境，奠基在大學中的新學科體認到科際合作的事實，而不該是被分化的。

在這種環境下，像易安·漢米爾頓·芬利（Ian Hamilton Finlay）這樣的藝術家，似乎沒有必要思考他們創作的到底是「造形藝術」或者是「具象詩篇」，因為二者間根本沒什麼差別。對雕塑發展的貢獻而言，最具原創性的是那些專注於與傳統不同素材的藝術家。理查·龍將他在鄉間漫步的愉悅轉化成藝術作品，部份是表演，部份是對透納（J.M. W. Turner）風景畫研究，留下地誌學的記錄。貝瑞·佛拉那格在傳統雕塑創作外，對具象詩、現代舞蹈和音樂，及

阿弗列德·嘉瑞（Alfred Jarry）的戲劇都有濃厚興趣。這些藝術能源是他創造出美妙並深富情感的雕塑的動力，而不是對前代英國雕塑家，像是卡羅、金或者包羅契的興趣或回應。紀伯與喬治是倫敦聖馬丁藝術學院的學生，與佛拉那格及龍是同窗。但是他們「活雕塑」的成功就較少受到當代影響，反而是源於英國美學的傳統：特別是在十九世紀末的藝術與工藝運動中，藝術被認為是屬於生活的，且負有改善生活的使命。

七十年代

六○年代末英國享樂主義盛行，取得社會主導地位的文化產品（包括流行音樂、劇場、電影或其他視覺藝術），在七○年代初已經接近尾聲。1973年經濟大蕭條，石油輸出國家組織決定限制原油產量，英國本身也發生煤礦工人罷工的危機，整個國家電力不足，陷入癱瘓。就英國而言，煤是特別重要的原料，因為在歷史上，煤象徵英國工業在十九世紀取得世界經濟的霸權。像在艾德華·奚斯（Edward Heath）保守黨政府時期完成的「不滿的冬天」，就訴說著英國後殖民繁景的終結。

後續幾年中，許多直接或間接以「社會議題」作主軸的藝術作品會獲得特別重視並不令人意外。像是「藝術與語言」這樣的藝術團體，將現代主義的理論與社會和經濟理論直接對立，不論是晚期資本主義或者馬克思主義。因為對許多藝術家來說，社會記錄的影像或者看板張貼的海報，似乎比較容易成為藝術作品，在家中或美術館完成的東西，則需要靠藝術市場的支持。不過七○年代，也是藝術關切「過程與材質」的盛行期。從某一角度來看，這類的藝術品遵從形式主義，似乎只關心構成作品的語言，只注重不同材料與技術所帶來的效果。但是，這種藝術實踐或許也反映了社會與政治情境：英國不再是過去那個以「過程與材料」來創造財富的工業國家。

卡羅的作品「鼓翼」，是由製造捲鐵的工業過程中，所產生的廢棄物組合而成。這個工業過程的背景是廢棄物回收，而作品所用的鐵即是由回收得來。值得注意的是雕塑本身並未上色：相對卡羅六○年代抒情享樂主義式的作品，「鼓翼」在調性上可說是一種全然的寫實主義。同時，對回

收材料與環境持續的關切，也可見諸於七〇年代英國威爾斯或蘇格蘭設置的許多雕塑公園，如英格蘭的馬干姆（Margam）、蘭德瑪克（Landmark）、葛茲岱爾（Grizedale）、西布列頓（West Bretton）等。這些公園中有種不可避免的傾向，那就是沒落的工業帝國與被工業極度扭曲的自然環境二者間的對話。在這種氣候下，理查·龍與漢米許·富爾頓（Hamish Fulton）的作品倍受注意，讓英國風景畫藝術，重回到全球環境關懷的中心。理查·龍基於一個現代主義者的樂觀想法與普遍主義，相信他的作品對任何文化背景的觀眾都是清晰易懂的。這與高度個人傾向，且有時過於褊狹的藝術家形成強烈對比；這些藝術家認為，只有像他們一樣的藝術家及繼起的世代，能在破碎分歧的「後現代」文化中成為主體。

「不滿的冬天」讓作為英國正統的現代主義瞬時結束，也引起一些幽默的回應，像是布魯斯·麥克林（Bruce McLean）的表演團體「精緻風格」（Nice Style），就以表演中純粹的能量與精巧也一樣贏得觀眾的喜愛（像紀伯與喬治），甚至讓觀眾覺得表演內容是愚蠢而荒謬的。受到沉重的「藝術為社會」與「過程與材質」的左右夾擊，英國藝術家自我嘲諷（也嘲諷他們的支持者）的功力受人肯定，而這也使他們繼續受到曯目。

到了七〇年代末期，一些微妙的轉變也贏得稱譽。代表英國參加1982年威尼斯雙年展的貝瑞·佛拉那格，以快速熟練的手法作出黏土模塑，再依據模型完成他的石雕作品，（由傳統工匠在卡拉拉切割）。從某個觀點來看，這些作品當然可以說是「過程與材質」的隨筆，就像具象詩只是具紀念價值的小品。不過從另一個觀點來看，它們也指出了另一個世代的道路，藝術家與市場之間逐漸形成諷刺的矛盾關係：藝術家不是出賣自己的勞力，而是將別人的勞力賣給資本家。

八十年代

七〇年代即將結束時，有一項匯集一群年輕雕塑家的展覽，參加的藝術家包括安東尼·貢利、比爾·伍德卓、安尼許·克普爾、理查·迪肯和理查·溫特渥斯。湯尼·克雷格雖然住在德國，但卻是靈魂人物。許多上述的藝術家

與克雷格相同，當他們開始受到外界注意的時候，都由里森藝廊代理。這些人相似的是，他們拒絕接受七〇年代雕塑發展所留下的岐異，就是不認為只能在注重「過程與材質」或「社會議題」二者間擇一。這些藝術家瞭解他們可以同時實現這二項任務。他們能純熟地發揮創作的過程與材質，同時汲取當代媒介所引發出的想像與內容來創作。

但是這群藝術家對於「材質與過程」的觀點，並不是工業時代，而是後工業時代－在日常生活中物品所使用的材料（通常再回收利用），他們使用這些材料創造影像或畫謎，加上手工為材料增添了第二層意義。有一陣子，雕塑家的手在創作過程中的處理（像是感覺或觸碰），對這種雕塑實踐轉變的觀點十分重要，但是這種想法在後來幾年中日漸式微，年輕一輩的雕塑家不再關注於此。

一個首先發展這種雕塑很好的例子是比爾·伍德卓的「車門，扶手椅與1981年的意外事件」，這件作品運用路旁發現的垃圾作素材，構成了一個敘事的時刻－也許是路邊發生的車禍也不一定？而1981年是倫敦部份地區與許多地方城市發生嚴重人民暴動的年代，原因是人民難以忍受政府政策，出現大量失業潮。伍德卓的素材取自社會每個消費者都隨手可得的東西：像是從玉米片盒子封面剪下的模特兒，B級電影中的意像與主題。而克雷格的作品「喬治與龍」，則是利用日常使用的「舊東西」，將它們與廢棄的彎曲蛇狀的管圈糾結在一起。

1981年同時也是倫敦皇家學院舉辦「繪畫新精神」展覽的年代。該項展覽標榜著英國「新意象繪畫」的到來。它們不僅主張繪畫是藝術表現的傳承與正當形式，（儘管錄影、照相及其他媒體在七〇年代，因為適合傳播與政治評論風行一時）而人像是一個持續被關注的主題。而在格拉斯哥藝術學院，也出了許多位企圖心旺盛的畫家，他們的作品與義大利超前衛派（Transavanguardia）的藝術家們有關，與英國較年長的前輩畫家則是有段距離。像是寶拉·瑞格（Paula Rego）、維特·威林（Victor Willing）、肯·基輔（Ken Kiff），或是在「繪畫新精神」展出的藝術家，如盧西安·佛洛伊德（Lucian Freud）、RB凱特吉（RB Kitaj）或大衛·哈克尼（David Hockney）。而人的身體，才是安東尼·貢利、安尼許·克普爾與蒙娜·哈同等人作品的重

心。他們雖然與前面提到的義大利與蘇格蘭藝術家同一世代，但是作品更有表演性－想要傳達的是，從個人與身體私密的經驗，延伸出更為廣泛的意義。

1979年瑪格麗特・柴契爾（Margaret Thatcher）雖然只有獲得40%的選票，但是她領導保守黨獲得英國政權。1981年的「福克蘭戰爭」，更讓她在隨後的大選中嚐到大勝的滋味。柴契爾擔任首相的期間，破壞了英國地方的自主與民主。但無疑地，這對倫敦的金融機構，以及密切相關的藝術品市場都有極大助益。而此時出現了「蠢錢」（silly money）這個詞，指的就是金融交易員所賺的薪水，許多藝術學校的學生，反而比較熱衷學習企業成功的模式，就像他們過去在學校裡學習各種技巧與藝術史。

茱利安・歐皮（Julian Opie）的作品「成功」，出現的時間正處於社會意識的幅轉點。它是由金屬鐵板切成像木板或者木工工具（螺絲起子，鑽子等等），塗上顏色後，用來代表工具正在對自己加工。這是一個俏皮的比擬，就像M.C.艾席爾（M.C. Escher）用自己的手畫自己，或是參考布魯斯・紐曼（Bruce Nauman）的「自己發聲的盒子」。這個作品的名稱，部份指涉性愛場景，但除此之外，更明顯描述了這些年的貪婪情境。像在作品「成功」之中，賺錢只是成功的一部份，但只有這部份才算數，同時什麼東西都得用自己的手去做（即使是錢），顯得有些過時甚至滑稽。歐皮在雕塑中企圖表達的哲學（或對藝術創作與藝術市場的態度－將藝術創作視為是一種行銷過程），是在他畢業的哥德史密斯藝術學院所經歷習得的。八〇年代，這所學院在瓊・湯姆森（Jon Thompson）、麥可・克雷格－馬丁和理查・溫特渥斯等的領導下，成為英國，甚至歐洲，最具影響力的藝術學校。

九十年代

八〇年代賺錢的狂熱，使得八〇年代末藝術市場對風險有了抗體。很多時候，商人就是藝術品保證人，他們是藝術家與市場間的緩衝機制。但是在倫敦金融市場，風險就發生在藝術家們認為可以跳過藝廊中介人，而直接與買主作生意。一個很有名的例子，是由戴彌恩・赫斯特與其他哥德史密斯學院的畢業生，在1988年舉辦一場名叫「凝凍」

的展覽，協助新世代的藝術家逐步發展。

1989至1992年間經濟蕭條，意味著許多藝術家得籌劃自己的展覽，因為經紀商已經關門大吉。莎拉・盧卡斯與崔西・艾敏（Tracey Emin）在霍克斯頓（Hoxton）開了自己的店，靠著她們個人的純粹信念，加上朋友的協助與認真來支撐。麥可，蘭迪取材自攤販，或市場攤位的陳列方式，形成了一件藝術品，與盧卡斯與艾敏開的店相似。而這件作品主張藝術是商品化的活動，如同「交易」、「事件」與「技能」支撐了藝術家的存在。

1991年的波斯灣戰爭讓美國走出經濟蕭條，老布希總統在民主黨前喊出新世界秩序的口號，隨後柯林頓總統接掌白宮。懷特雷、赫斯特與葛登三位藝術家，他們的作品屹立在九〇年代初期。為了反對愈來愈多人使用「風格」來販賣政治觀點，懷特雷的雕塑似乎根本沒有所謂的「風格」，有的是早就退流行的情感與鄉愁。她對素昧平生的人的親密記憶，是對矯情造作的政治領袖最有力的譴責，政治領袖妄言改變一切，更不用說是要創造新世界秩序。赫斯特的作品自九〇年代初期，就以死亡為主題，以死亡作為異化的隱喻，作為疾病或偏執狂的一種形式，而不再只是毀滅而已。葛登則是利用心理治療所內的電影片段，以平行的手法探討政治理論與修辭中的「下層階級」：經過了九〇年代，富人與窮人的差距是愈來愈大。

許多評論指出，目前英國的貧富差距是十九世紀以來僅見。如果社會真是一體，縮短貧富差距的答案，就在購買樂透彩券或者參加快速致富的電視節目。於此，我們似乎又重回感傷且不幸有點偽善的維多利亞時代。而麥特・克里修似乎從英國維多利亞時期的豐富傳統中，挖掘許多作品的靈感：前拉斐爾主義或查理・狄更斯「聖誕之歌」的回音似乎就是非常後現代式的追悼，呈現了那些被排除在任何政治階層之外的生命，就像瑞秋・懷特雷的作品一般。

1992年普選之前，約翰・梅傑（John Major）取代了瑪格麗特・柴契爾成為保守黨領袖。梅傑是位高尚，熱愛運動，但卻很乏味的人。繼任首相的他，重新與北愛爾蘭簽署和平協定，除此之外，梅傑政府的重大成就似乎就是發

行國家彩券。媒體反映彩券贏家如何享受財富，增強大眾的興趣。雨後春筍的電視頻道與必然發生的觀眾爭奪戰，結果造成了節目水準的普遍低落，有愈來愈多的頻道放映聳動的節目。個人秘密的告解或犯罪場景，電視都有現場直播，同時一些「老大哥」式的電視節目大為流行，一群被限制行動自由的人，日夜互動的過程一一呈現在觀眾面前。

梅傑政府輸掉政權的時候，是輸在「行為不檢」（sleaze）－政客沒有成功地對大眾保留私生活中不能接受的細節，也沒有去承擔公眾對其生活所要求正直廉潔的高標準。東尼‧布萊爾（Tony Blair）的「新工黨」政府在1997年進入白金漢宮，現在主要是以「避重就輕／轉移焦點」（spin）聞名－不論事情的實際狀況，總是秀出自己燈光下好看的那一面。布萊爾取得政權後不久，政府推展「酷大不列顛」活動，推崇英國創意與設計工業的廣大影響力。但是任何這項活動可能產生的正面效果，卻被「自貶身價」（Dumbing Down）這個輿論所淹沒，（意即降低水準，為了讓更多觀眾與社會成員參與）。

九○年代晚期的藝術在以上的脈絡中成形，從中汲取了內容。這些作品可說是個人關懷的公眾告解。（一項以查爾斯‧薩奇（Charles Saatchi）收藏的近代英國藝術品為對象的展覽，名稱就叫做「色羶腥」，在倫敦與紐約都有許多觀眾參觀。）看來想把普通的創意或平庸的事實，轉化成有意義而令人眼睛一亮的事件，的確需要「避重就輕／轉移焦點」的功力。

許多九○年代的人，都有一個容易發現的共同點，那就是對個人及個人政治的關切，而這似乎又回到了六○年代末或七○年代初。嘲諷並不流行，直言坦率才受人讚許。蒙娜‧哈同致力於個人政治，首次印證在她七○年代的表演，在當時可說十分優異。而安雅‧葛拉契歐也有極詩意但暫時性的作品；莎拉‧盧卡斯享受雙關語的樂趣，她關切（國語／方言）的問題，也投入了「自貶身價」的辯論；崔西‧艾敏（Tracey Emin）選擇曝露自己的生活；吉莉安‧威爾靈（Gillian Wearing）自我告解的錄影帶，似乎都與九○年代的情況相當吻合。當九○年代即將進入尾聲，藝術家的作品似乎較能和時代銜接，沒有那麼多黑暗氣

息，比起戴彌恩‧賀斯特、馬克‧昆恩（Marc Quinn）或麥特‧克里修來說，已較不關心死亡與異化的問題。

無論當下何種英國藝術受人矚目，對我來說，可以肯定的是，它一定會是綜合社會大多數人的關切；不管是什麼新的表達形式，都難免受到內容的牽制，但也將由其內容出發創新。（翻譯: 屈享平）

（路易斯‧畢葛為前任泰德美術館利物浦分館館長，現為利物浦雙年展主席）

"Square Bashing"
An Introduction to Sculpture in Britain 1960-2001

Lewis Biggs

(Note: 'Field Day' is the name given to military manoeuvres carried out in peace time - ie training 'in the Field' instead of in barracks. The phrase is used by extension to mean an 'easy victory' in war time, as in 'a walk over'. But it also has connotations of fun or celebration: children in a playground slightly out of control might be said to be 'having a field day'. 'Square Bashing' is slang for doing military exercises in barracks, but in this context it refers to the antipathy between the traditions of art in Britain and the tradition of formalist and abstract art deriving from Malevitch, Mondrian etc.)

British sculpture has been celebrated internationally since the last mid-century for its formal innovation - including its appropriation of the media of photography, video, installation and performance art. ('Sculpture' in Britain nowadays tends to be used loosely to mean all the visual arts that are not painting.) It is likely to be the strangeness and diversity of the forms of 'sculpture' in this exhibition that attract attention from viewers in Taiwan. When faced with the unfamiliar, what we experience is always the formal - the shapes of things. We feel we can appropriate the exotic simply by copying its forms. Very often, that is all we want from it, the sense of exoticism, and the form is enough. But then, of course, the content is lost.

However, I believe that British culture, including the fragment of it addressed in this exhibition, is primarily created by and for its content with form as a secondary consideration. The idea that art should 'say' or 'be about' something is deeply ingrained in the British mind. Secondly, spoken and written language are generally more powerful in British culture than is visual language, and the visual arts are to that extent influenced in their content by narrative and by rhetorical devices including humour (especially punning) derived from verbal language.

In this introduction for Taiwanese visitors to the exhibition, I try to suggest how to guess at the content behind the forms, through providing some of the wider cultural context in which the artworks were made. While the selection of artworks for the exhibition favours the recent past, I have tried to give equal emphasis to the four decades under consideration.

The Sixties

Britain in the 'Swinging Sixties' was a good place to be young. As the war years (1939-45) gradually receded, so did the rationing and other restrictions on consumer life the conflict had produced. Cheaper cars and then cheaper air transport allowed larger numbers of people to travel for pleasure. Europeans came to England to meet 'America', and Americans came to England to meet 'Europe'. It was a crossroads of cultures. When the poet Allen Ginsberg visited the port of Liverpool in the mid sixties, he declared it the 'centre of consciousness of the Universe'.

The terms for making art in Britain in this decade had been set in the fifties by artists working in New York, then the most important market for art in the world. Although some British artists and critics argued that the British examples of Pop Art and of Lyrical Abstraction were as important as the American ones, the terms of the debate which elevated these styles to prominence had been set in the USA. And by contrast, the still vigorous realist styles of art practised in England in the sixties received little international attention.

Paolozzi's European version of Pop Art engaged with the traditional artists' crafts, alluded to classical literature and had 'tragic' ambition. Much of it is a meditation on the impact of technology on traditional values. The American version of Pop, conversely, was happy to reinvent technical processes, was strictly contemporary in its allusions and hedonistic in its message. Had there been space in the exhibition to show figurative sculptures from the sixties by Bruce Lacey, Allen Jones or George Fullard, these would have provided a context for Paolozzi's work. They would have emphasised its theatrical qualities, especially its humour and satirical edge, over its formal ones (the colourful futurism that still speaks to us directly today). Paolozzi himself preferred to be seen not as a surrealist or Pop artist but as a 'realist'.

Anthony Caro has always acknowledged the influence of the New York lyrical abstract painters on his work, as well as the formalist theories of Clement Greenberg. But to leave the story there would be to miss the energy that drives the sculpture. That energy comes from a humanist concern, and an interest in constructing expressive gesture. What those gestures mean is less clear - there is no sense of a programme, as there is in Paolozzi's work - but can perhaps be best understood through Caro's own preferred analogy, with music. Music is able to move us without overt content: the content is the emotion it evokes. *Sculpture Seven*, made the year after Caro's first visit to New York, shows American influence on his work at its height: in its emphasis on bold simplicity of structure, and simple, strong colour. *Month of May*, made just two years later is very different, with an 'English' delicacy of line and colour as well as the sense of poetic allusion in the title.

The rising prosperity in England of the sixties allowed people to replace the consumer goods that had served them for years with new goods made in technically innovative materials - plastic crockery or furniture, for instance, replacing china or wood - often also produced in bright colours . The potential uses of 'plastics' such as glass fibre set in resin were very seductive to some sculptors, and Phillip King was among those who for a while embraced warmly the new materials and their potential for colour. Bronze is sufficiently expensive as a material for a purchaser to want to know that it really is bronze. Plastics have little intrinsic value, and so can accept an intensity of expressive colour on their surface without 'devaluing' the material. King, like Caro, had made figurative sculpture before making abstract art. Abstraction was thought of then (as often now) as a move away from the limitations of a 'subject'. In fact, the move was from one kind of subject to another - in this case the subject is a conversation about the possibilities of creating a metaphor in shapes and colours for a conventionally poetic subject. Rosebud and Ripple have an emotional intensity as objects in excess of their poetic origins.

I mentioned the poet Allen Ginsberg above because the sixties was a moment at which the mingling of different art forms became a key issue: Jazz musicians and 'Beat' writers and poets mixed with fine artists (two of the Beatles pop group were trained as fine artists). In this context Clement Greenberg's formalist claims for the autonomy and purity of art practice appeared highly reactionary. It was the decade in which students 're-volted' in England, as elsewhere, to demand some participation in the terms of their studies, and 'ecology' was founded as a new discipline at many universities in recognition of the fact that the sciences needed to work together rather than separately.

In this context there seemed no need for artists such as Ian Hamilton Finlay to concern themselves as to whether their work was seen as a 'plastic art' or 'concrete poetry'. What was the difference anyway? Some of the most original and innovative contributions to the development of 'sculpture' came from artists whose interests encompassed traditionally separate media. Richard Long turned his enjoyment of walking in the countryside into an artwork, part 'performance', part topo-graphical record with antecedents in the landscape studies of J.M.W. Turner. Barry Flanagan was as much interested in concrete poetry, contemporary dance and music, and the theatre of Alfred Jarry as he was in traditional sculptural practice. His wonderfully poetic sculptures derive their energy from these sources rather than any interest in or reaction to the preceding generation of British sculptors such as Caro, King or Paolozzi. Gilbert and George were students at St Martin's School of Art in London along with Flanagan and Long. But the influences that led them to their career as 'living sculptures' were perhaps less contemporary and more embedded in the English aesthetic tradition, especially the Arts and Crafts Movement of the end of the nineteenth century, in which art was conceived as a moral mission encompassing the whole of life in order to improve it.

The Seventies

The determined hedonism of the late sixties in which cultural production (popular music above all, but also theatre, film and the other visual arts) seemed to have taken centre stage in society ended quickly in England in the early seventies. In 1973 there was a severe economic recession induced by the OPEC countries' decision to control production outputs of their oil, and in England itself by a coal miners' strike that brought the country to a standstill through power shortages. Coal was a particularly important raw material symbolically for Britain because of its historic link to the manufacturing industries that had given England a dominant position in the economy of the nineteenth century. This "Winter of Discontent" under Edward Heath's Conservative government spelled the end of an era of post-colonial prosperity for the UK.

It is not surprising that much of the art receiving critical attention in the following decade addressed 'social issues' either directly or indirectly. Artists' groups such as Art and Language forced modernist theory into direct confrontation with social and economic theories, whether late capitalist or marxist. For many artists, social documentary photography and posters made for billboards seemed a better way to make art than domestic or museum artworks requiring an art market to support them. However, it was also the decade in which art concerned with 'process and materials' flourished. From one point of view this kind of art is formalist, apparently concerned only with the language of making, the effects of different materials and techniques. However, perhaps this kind of art practice was also reflective of the social and political situation: a concern that Britain was no longer pre-eminent in the 'processes and materials' that had created its wealth as an industrial nation in the past.

Anthony Caro's *Flap* is composed of the discarded waste from an industrial process for making rolled steel, and the context of this process is recycled along with the form of the steel in his sculpture. Significantly, there is no colour applied to this sculpture: the mood is one of stark realism in contrast to the lyric hedonism of his art in the sixties. Concern for recycling materials and for the environment more broadly was evident in the founding of many Sculpture Parks in the UK in the seventies - in Wales and Scotland as well as in England (Margam, Landmark, Grizedale, West Bretton). In these parks, there was an inevitable tendency to meditate on the dialogue between an industrial empire reaching the end of its life and what was left of the natural environment that had been so altered by industry. In this climate, the art of Richard Long and Hamish Fulton gained great currency, setting English land-scape art back at the centre of global environmental concerns. Richard Long's belief that his art is legible by people in any culture is based in a modernist optimism and universalism. It makes a stark contrast to the highly personal and sometimes parochial concerns that many other artists of his own and the succeeding generation felt were the only possible subjects in a fragmented 'post-modern' culture.

The sudden end of modernism as an orthodoxy in Britain as a result of the "winter of discontent" produced sometimes humorous responses, such as Bruce McLean's performance group "Nice Style". The sheer energy and finesse of their performances (as of Gilbert's and George's) forced admiration from an audience who may nevertheless have thought the content frivolous or inconsequential. Alongside the weighty 'issues' of 'art for society' on the one hand and 'process and materials' on the other, the welcome ability of British artists to laugh at themselves (and their patrons) continued to make itself felt.

By the end of the seventies, a certain lightness of touch began to be highly prized. Barry Flanagan, who repre-sented Britain at the 1982 Venice Biennale, showed his stone carvings (carved by traditional craftsmen in Carrara) based on ephemeral sleights of hand modelled in clay. From one point of view these were, of course, essays in 'process and material' as well as concrete poetry, a monumental insignificance. But in another they

pointed the way forward to a decade in which a sense of irony between the artist and the market came to predominate. The artist was selling someone else's labour, not his own, to the capitalist.

The Eighties

At the very end of the seventies, there emerged a group of younger sculptors that included, from this exhibition, Antony Gormley, Bill Woodrow, Anish Kapoor, Richard Deacon and Richard Wentworth. (Tony Cragg was a pivotal figure despite the fact that he lived in Germany, and most of these artists joined Cragg in being represented by the Lisson Gallery once their work began to attract critical attention). The link between them was their refusal to accept that their art should take one of the divergent paths of the seventies: focused on 'processes and materials' on the one hand or focused on social issues on the other. These artists realised they could do both at the same time. They could use the techniques of art in which processes and materials were paramount, along with imagery and content drawn more directly from contemporary media.

However, their preferred 'materials and processes' were not industrial but post-industrial, materials that carried associations of their everyday use - often recycled - and they used them to create images or rebuses to add a second layer of meaning or reference through their own handiwork. This sense of the artist's own hand (sensibility, touch) was important for a while in the transformative aspects of this sculptural practice, although it weakened in the next few years and became irrelevant for a slightly younger generation.

A fine example of the first explosion of this kind of sculpture is provided by Bill Woodrow's Car Door, Armchair and Incident 1981 made from materials that suggest rubbish found by the roadside composed into a narrative moment - a driveby killing perhaps? 1981 was the year in which serious civil riots took place in parts of London and several of the regional cities in which the unemployment created by government policies was most grievous. Woodrow's sources are the immediate ones available to every consumer in society: the techniques of cutting models from cereal packets, and the imagery and subject matter from which 'B' movies are composed. Cragg's George and The Dragon, in this exhibition, takes 'old' objects of practical use and shows them entangled in the serpentine coils of consumption and waste.

1981 was also the year of A New Spirit in Painting, an exhibition at the Royal Academy in London which marked the arrival of New Image painting in Britain. It asserted not only that painting was a continuing and valid form of artistic expression (despite the popularity in the seventies of video, photography and the other media suited to political commentary and mass distribution) but also that there was a continuation of interest in the human figure as subject. Glasgow School of Art produced some ambitious painters whose work had more obvious links with the 'Transavanguardia' artists in Italy than with older figurative painters in Britain, such as Paula Rego, Victor Willing, Ken Kiff, or the artists included in A New Spirit such as Lucian Freud, RB Kitaj or David Hockney. The human body is at the heart of the work of Antony Gormley, Anish Kapoor and Mona Hatoum. They are broadly of the same generation as the Italian and Scottish artists just mentioned, but their art is more closely based in performance - or at least in the extrapolation of a message of wide significance from a personal and private bodily experience.

In 1979, Margaret Thatcher led the Tory party to victory despite polling only 40% of the electorate, and the Falklands War of 1981 assured her of a sweeping victory in the election that followed. Thatcher's period in office was destructive of local democracy and of the regions of England, but there is no doubt that it benefited the City of London's financial institutions and, consequently, the art market. This was the moment when the term 'silly money'

began to be applied to the salaries earned by financial dealers, and many art students were as keen to learn about models of success in business as they were the techniques or history of art.

Julian Opie's *Making It* is set wonderfully at the axes of social conscience of the time. It consists of steel plate cut to the shape of, and painted to represent, wooden planks with tools (screwdriver, drill etc) 'at work on itself'. It is a witticism like M. C. Escher's hands that draw themselves, and also perhaps a reference to Bruce Nauman's *Box with the Sound of its own Making*. The title refers partly to the act of sex, but beyond that, and much more tellingly, it refers to the mood of greed in those years. Making money was only a part of making 'it' but it was the part that counted, and to make anything with your own hands (even money) was somehow a comical and outmoded activity.

The philosophy (or attitude to the making and marketing of art - or the making of art as a marketing process) that Opie exemplified in this sculpture was learned at Goldsmith's College of Art, of which he was a graduate. During the eighties, this College became, under the teachers Jon Thompson, Michael Craig-Martin, and Richard Wentworth, the most influential art school in Britain, and perhaps in Europe.

The Nineties

The money-making frenzy of the eighties ensured that by the end of the decade the art market began to become immune to the idea of risk. It is usually the dealer that acts as the guarantor for art, and the buffer between artist and market. But the mood of risk-taking in the London financial markets was such that artists felt they could by-pass the middle-man of the gallery / dealer and sell direct to the buyer. A famous example of this process was the exhibition *Freeze* organised by Damien Hirst and other graduates of the Goldsmiths College in 1988,

helping to launch a new generation of artists in the process.

The recession, when it came in 1989/92 meant that many of these artists had to continue to organise their own exhibitions, because the dealers had gone out of business. Sarah Lucas and Tracey Emin set up their own shop in Hoxton, sustained through sheer belief in themselves, a little help from their friends and a serious ability to party. Michael Landy's appropriation of market stalls, or the setting up of market displays, as artworks, like Lucas' and Emin's shop, maintained the focus of art as a commodified activity, sustaining the artist as much or more by 'trade' or 'event' as by 'craft'.

The Gulf War of 1991 gave the necessary impetus to get the USA out of recession, and President Bush was able to announce his New World Order before the Democrats and President Clinton came to power. Three artists whose work seems to stand at the opening of the decade of the 1990s are Whiteread, Hirst and Gordon. In counterpoint to the increasing use of 'style' to sell political points of view, Whiteread's sculptures seem style-less and even to have some of that most unfashionable emotion, nostalgia, about them. Her intimate memorials to people she had never met seem the most powerful rebuke to the pretentions of political leaders that they can change anything, let alone create a new world order. Hirst's work from the start of the nineties appeared to be focused on death, but death as a metaphor for alienation, death as a form of sickness or paranoia rather than death as extinction. Gordon's appropriation of film footage from psychiatric hospitals is a parallel exploration of the 'underclass' that has come to characterise political theory and rhetoric as the nineties wore on and the gap between rich and poor opened ever wider.

It is often remarked that the gap between rich and poor in Britain now has reached levels not seen since the nineteenth century. The response in society as a whole is to focus on the Lottery or on television programmes that promise quick riches. The sentimentality and unfortunate hypocrisies of the Victorian

era seem to have returned, and it is this rich vein of national tradition that seems to be mined by some of Mat Collishaw's work. Echoes of Pre-Raphaelitism or of Charles Dickens' *A Christmas Carol* seem to emerge in these very post-modern memorials that, like Rachel Whiteread's, are for the people whose lives have never been represented at the level of politics.

Before the General Election of 1992, Margaret Thatcher was replaced as leader of the Tory party by John Major, a decent, sports-loving but rather colourless personality, who became the next Prime Minister. Along with renewed efforts to reach a peace settlement in Northern Ireland, a significant legacy of the Major government now seems to be the creation of the National Lottery. The media reflected and increased the public interest in how a winner of the Lottery managed to live with their new riches. The multiplication of television channels and the ensuing battles for viewing numbers resulted in a general lowering of standards of broadcast, with more and more channels screening increasingly sensational programmes. Confessions of personal secrets, or crimes, live on television, or 'Big Brother' programmes in which enclosed groups of people are watched in their interactions day and night, became fashionable.

The Major government, when it was defeated, was brought down by 'sleaze' - by politicians being unable to keep the unacceptable details of their private lives out of public view, and by increasingly high levels of accountability being brought to bear on the probity of public life. The 'New Labour' government of Tony Blair, which came to office in 1997, is now famous chiefly for its devotion to 'spin' - for the ability to present itself in a good light no matter what the actual facts of the situation are. Soon after taking office, the government launched its "Cool Britannia" campaign to recognise the widespread influence of Britain's creative and design industries. But any positive effect this might have had was submerged in the wider public debate about "Dumbing Down" (that is, lowering

standards in order to ensure larger audiences or greater 'social inclusion').

The art of the later nineties was formed within this context and takes much of its content from it. There are confessions in public of private concerns. There is a tendency to sensationalism. (The exhibition of Charles Saatchi's collection of recent British Art called "Sensation" gained high levels of visitors in both London and New York.) There is much 'spin' to turn ordinary ideas or unremarkable facts into 'significant' and attention-grabbing events.

The most noticeable feature shared by many of the nineties generation is a concern for the personal, and the politics of the personal, that seems to reach back to the end of the sixties or early seventies. Irony is unfashionable, gut-wrenching sincerity is given due credit. Mona Hatoum's devotion to the politics of the personal first evidenced in her performance work of the seventies seems very much of the moment. Anya Gallaccio's poetic and ephemeral artworks; Sarah Lucas' enjoyment of punning, her concern for the 'vernacular' and engagement with the debate around 'dumbing down'; Tracey Emin's exposure of her own life; Gillian Wearing's confessional videos, all seem very close to the mood of the nineties. As the decade drew to a close, it was the work by these artists that seemed more truly in tune with the times than the dark but less personal concern with death and alienation to be found in work by Damien Hirst, Marc Quinn or Mat Collishaw.

Whatever current in British art next catches the limelight, it seems certain to me that it will be highly attuned to the concerns of society at large, and that whatever innovations in form that emerge, they will be not only conditioned but created by its content.

沉靜而詩意的「異國情調」：從台灣看大不列顛現代雕塑

張芳薇

遠在歐洲的大不列顛英國，對居住在亞洲的台灣民眾而言，具有一種沉緩迷人「紳士」般優雅的刻板印象與魅力-英國是‧‧‧‧彬彬有禮的紳士、披頭四、Pub、英國腔的英文與幽默感、綠草如茵丘陵起伏靜謐的田園、牛津、莎士比亞、黛安娜王妃、工黨與下午茶等等。除此而外，相較於台灣的生活與一般速度，英國有一種斯文而沉緩的特質，彷彿，急急忙忙等於沒品沒文化沒教養一般。這是英國獨特的時間觀。另外，就是著名的英國式「收斂」（reserved）態度，常聽英國朋友說：「我們不是保守，我們是收斂。」這樣的態度使英國並不急忙跟隨其他國家的腳步，例如：對於是否加入歐元，先持保留看法觀察一陣後再決定。由此可看出其民族性穩重慎重的特質。以上都是由台灣看大不列顛膚淺的印像與想像。

就在不久之前電腦資訊科技尚未如此發達，人們無法常常旅行，對遙遠的「彼方」多具有特別的想像與期待，這樣由文化差異與地方的距離造成的想像與期待也形成所謂的「刻板印象」與「異國情調」，兩種對其他文化膚淺認知的負面描述。以前的異國情調是形容因距離而產生的對他文化的想像與期待，比較負面，現在，在全球化的影響下，我們正在嘗試「共享異國情調」，其意義也逐漸比較正面。其實，異國情調既無可避免，也無可後非，也可說是人之常情。重要的是這樣的想像與期望是否帶來更深一層的文化分享、交換與融合，而非停留在表象。從近日西方觀眾喜歡台灣電影「臥虎藏龍」，可知人們總是在找尋「不一樣」的東西。當具有異國情調的彼方成為自己可供參照的鏡像時，也同時提供我們進一步與之對話與反觀參照自己的機會。藝術是溝通的中介，觀眾欣賞作品先從形式著手，再聽（或讀）「故事」。故事非常重要，隱含作品的內容與作品產生的背景，使觀者能依之而反觀自己的文化與社會狀況，使閱讀作品不再流於表面形式而達到文化交流的目的。

「雕塑」在英國

「靜觀其變」（註）(本項展覽的英文名稱是 FIELD DAY，涵義詳路易斯‧畢葛文章)以英國現代雕塑視覺化、平面化、非物質化、觀念化為題旨，展出六○年代至二○○一年英國雕塑發展的演化與變遷。英國現代雕塑是英國現代藝術

各項發展中最受國際藝壇肯定，發展脈絡最完整而堅實的一支。早在維多利亞時代，英國即已有非常優秀的戶外雕塑傳統，為了彰顯大英帝國的強盛權勢與富裕，選擇了非常昂貴而不朽的方式－大量委託製作各發展中城市的戶外公共雕塑，如此而奠下英國優秀的戶外雕塑傳統。雕塑，在英國建立了某種大英帝國的主體形象。英國現代雕塑自亨利‧摩爾以降，即人材輩出，廣受國際藝壇肯定，而且，每個世代對「雕塑」這個藝術形式觀念的演化與發展都有特別的貢獻。

以「雕塑發展」為題旨舉辦二十世紀下半期的雕塑展，從英國著手實在非常適合。理由蠻複雜的，除了因英國原本即有雕塑傳統外，也由於英國人向來喜歡認真辯論 -- 圍繞著某項議題做持續認真的討論。而最適合辯論的場所往往是學校與課堂，所以六○年代起的英國雕塑發展與倫敦數所藝術學院（例如歌德史密斯學院與聖馬丁藝術學院）和老師兼雕塑家的持續關注有關。這樣的情形在美國或歐洲其他地方較不容易發生。雖然透過不斷超越前人擴張雕塑的圖版，持續討論雕塑卻變成英國藝術界的另一項「傳統」（英國是十分重視傳統的國度），如此才有可能累積幾個世代的雕塑成果。

在英國，六○年代是個熱烈討論雕塑定義的時代，而卡羅繼亨利‧摩爾及芭芭拉‧海普渥斯等雕塑家之後，將雕塑「抽象化」做了更大的擴張，並培養下一代的年輕藝術家，六○－八○年代，在卡羅及其後的年輕數代雕塑家前仆後繼的努力下，大大擴張了雕塑的版圖。許多雕塑家所創作的雕塑不再以「自由站立的物體」呈現，而是以「平面」－攝影、文字敘述、電腦輸出、錄影裝置甚或表演的方式展出。對雕塑材質與過程也加以深入的探討而反映在藝術表現上。而且，八○年代的雕塑家已對雕塑本身純粹的美學觀照不再感興趣，而是希望從事「總體」的藝術創作，希望雕塑具有更寬廣的意涵，可同時探討更多面向－如政治、社會方面等的議題。

大不列顛的雕塑詩情

英國雕塑發展豐富多元，莽撞歸類或以貼標籤的方式牽強斷言其文化與藝術性格是極不恰當的。不過，當展示的時

空與面對的觀眾不同時，英國現代雕塑確也總是能呈現出沉緩詩意而靜謐的集體意識的風格。因為沉緩，可以沉吟，也才來得及對話。因為詩意而形成較大的想像空間。八○年代的「新英國雕塑」世代常被稱為「詩意的物體」(poetic objects)最能代表此種特質，在本展所包括的理查•溫特渥斯、湯尼•克雷格、安尼許•克普爾、理查•迪肯、比爾•伍德卓、安東尼•貢利等都屬於這個世代。往前回溯，卡羅與菲利浦•金六○年代起的雕塑也都具有這項特質。卡羅作品中特殊的色感、平滑的表面與輕盈結構所散發的抒情性在其後數代的藝術家作品中都持續著。菲利浦•金直言顏色對他的創作而言非常重要。這樣精微的集體風格與英國人重視人與大自然的關係有關（又是一項傳統），與其他地區的發展不同。九○年代的英國雕塑雖然有更多元的發展，但是瑞秋•懷特雷的獲重視─雖然是由於她的創作觀念性很強，多少也顯示英國仍然在某部分戀棧詩意的雕塑實體，實體的雕塑仍然是顯學的一部份。她翻鑄的雕塑體給觀者似曾相似超現實的感覺，純粹而靜謐。從她翻鑄的建築物，人們發現傳統雕塑的「紀念碑」特性與雕塑性仍然存在，或者說，又回來了。

英國人重視人與大自然的傳統使英國雕塑較之於其他西方國家（特別是美國）更具有「人」的尺度。雕塑的大或小與人的尺寸有關，是人性的而不是絕對的，毫無炫耀的意圖。在英國也比較沒有絕對大的雕塑。本展包括了數件機智慧詰的小雕塑如理查•迪肯的「為其他人而做的藝術系列」與比爾•伍德卓的小物體等。雖然本展因展覽選件必須有所取捨而無法包括如漢米爾頓•芬利(Ian Hamilton Finlay)、大衛•納許(David Nash)或富爾頓(Hamish Fulton)等與大自然比較直接相關的創作而只包括理查•龍。但是，英國現代雕塑整體在某個程度上仍可說與自然有關。例如，英國雕塑時常被稱為具有突出的「地板性」（直接站立於地面），固然是因為二十世紀雕塑發展的「自然」結果（雕塑從台座上走下來），卻時常使觀者聯想到「大地」或「地面」，例如湯尼•克雷格雖然以都市中（相對於大自然）撿拾到的小物件經過處理上色後排列展出，他緊貼地面的雕塑明顯地使觀者想到「大地」而不只是自然─自然與大地在意義上仍不相同。在此自然與城市（非自然）的辯證關係變成了「大地」或更廣義的生存環境。

日常消費物品的延伸

如果說六○─八○年代的英國雕塑發展是傳統雕塑的延義與雕塑視覺化的過程，九○年代便可說是日常消費物體的延伸與跨領域的再次結合。九○年代英國藝術發展以戴彌恩•赫斯特所策劃的「凍凝」展(Freeze)後所造成的「年輕英國藝術家」(young British artists)世代為經緯廣受世界藝壇稱道。包括在本展的除策展人赫斯特外，其他如麥可•蘭迪、莎拉•盧卡斯、安雅•格拉契歐與麥特•克里修都參加了「凍凝」展。雖然關注的議題與內容各異，這些藝術家有蠻大比例都挪用現成品，直接將平凡物體搬上藝術檯面，企圖賦與某種深刻意涵，使藝術與生活的藩籬不再，並且，將現成品的觀念更擴大而形成如設立「藝術家公司」般的系統，如麥可•蘭迪的「廢棄物處理服務公司」(Scrapheap Services)。九○年代可看到極端化與極端個人化的藝術表現，不論是批判政治、或批判消費社會，整體表現似乎較之於前幾個世代輕巧、樂觀與明快。這是國際性的趨勢，是全球化下的效應之一。

屬於英國的叛逆與敗德

英國藝術在世界藝壇常有異軍突起的叛逆表現。這可說是屬於英國的藝術爆發力。從台灣來看最直接的聯想是眾所週知的披頭四音樂或是近年的英國電影「猜火車」(Trainspotting)。通常，這樣的判逆表現企圖挑戰當時的權威，挑戰一般的道德標準，也可能在呈現上有些敗德或驚世駭俗。惡名昭彰的紀伯與喬治可謂在六○年代起即具有英式的叛逆性，他倆所做的「唱歌的雕塑」將雕塑完全解放，與德國的波依斯所提出的「人人都是雕塑家」可說具有異曲同工之妙。「唱歌的雕塑」的風格混合了英國劇場文化、英國紳士與英式幽默等，其藝術表現對當代的雕塑語彙做了重要的突破，也融合了傳統在地文化。柴伯曼兄弟以「讓觀者極度嫌惡」為創作標第之一。他們所做的如妖怪般的多頭青少年裸體群像在展覽場引起騷動與衛道人士的韃伐，以充滿嘲諷的表現回應光怪陸離的當下社會狀況。這在英國並非個案，也有其前身與傳承。例如多頭青少年裸體群像使我們想起七○年代巴特勒(Reg Butler)的上彩具像雕塑。其他如戴彌恩•赫斯特的防腐動物切片當然也曾

引起英國社會普遍討論。這種情形使我們想起一禎宣傳英國的照片：傳統打扮的父母與叛逆前衛龐克裝扮的兒子相安無事生活在同一個屋簷下。這是一種值得驕傲的，對異己包容與尊重個別發展的隱喻。

雕塑的非物質化

當雕塑以錄影紀實、記錄性的攝影與書寫文字合法展出後，雕塑便真正圖像化、平面化了。觀眾到展覽場欣賞掛在牆上的「雕塑意象」，觀賞麥克・克雷格－馬丁「畫」或「貼」在牆上的電燈泡、尺規、地球儀、椅子等日常物品，魅惑於道格拉斯・戈登所製作非常「物體性」的影片，或觀賞安雅・格拉契歐的去物質性的彩虹時，「實體」意像化、影像化、觀念化了！雕塑是什麼？可能只是強調「繪畫性」時的相對應－雕塑性；可能只是人們記憶中的心像，或者說，是相對於人類身為主體的客體－物象，更或者說，是提醒人類自身存在的「鏡相」罷了！

由距離與私密性形成的主體性

由於英國在歐洲自成一個島國，與歐陸維持一個距離，政經人文及藝術都有其獨特的發展。英國的現代雕塑發展在許多層面也顯現出這個島國所具有的獨特美學觀照－距離，這也成為其獨特的美學符碼之一。距離可以由許多方式造成。以個別藝術家的表現而言，安東尼・卡羅以他的高彩度、平滑的雕塑表面壓抑了觀眾觸摸的慾望，製造與觀者之間的距離；卡普爾的粉狀質感雕塑表面引起觀者觸摸的慾望，卻是真正「禁止觸摸」，「禁止」造成「距離」；赫斯特以各式各樣的「箱子」區隔了人（觀眾）與作品，除此以外，他最被引起爭議的作品是以箱子裝著浸泡在防腐液的動物切片，造成觀眾心理上的不安與驚人的視覺效果，作品本身即標示距離；「距離」成為作品內涵一部份的尚有理查・龍，他展出特定地點作品的地圖、攝影與相關資料，原來的創作過程神秘地只有藝術家自己參與，作品以高度私密性與隱密性造成高度的距離感與主體性。「距離」產生主體性，「距離」包含時間及空間。湯尼・克雷格利用工業社會的廢棄物所排列組合的作品，每一個小單位都以自己的方式獨立存在，每一個小單位都與其他的部份

維持一定的距離（這樣的次序感不由得使人聯想到英國人蠻耐心於排隊，人與人之間也不會互相推擠）。這個距離，是實際的也是心理的，距離可以很大，也可以很小。

對話－距離的消融

距離既形成主體，也形成主客雙方的想像空間，這樣的美學觀照提供本項展覽一則隱喻；台灣與英國之間的「距離」提供了台灣觀眾透過「異國情調」的鏡像一個反省自身生存處境與狀況的機會。特別是，台灣並沒有經歷英國這般的現代雕塑發展歷程，本項展覽提供了一個雙方的對話機會。當觀眾面對作品，主客便可能透過對話合而為一，距離隨即消融。

註：本展中文展名訂為「靜觀其變」，是因為英文展名「FIELD DAY」（演習日，也有慶典之意）對台灣觀眾比較唐突，為因地制宜，故以「靜觀其變」為名。

Exotic Poetry: Modern British Sculpture from a Taiwanese Perspective

Fang-wei Chang

Seen from Taiwan, Britain holds a captivating, though stereotypical "gentlemanly" grace and charm. For most Taiwanese, England represents suave gentlemen, the Beatles, pubs, English spoken with a lilting accent, the dry English sense of humor, verdant rolling hills and fields, Oxford, Shakespeare, Lady Di, the Labour Party, and afternoon tea. Other than these impressions, in contrast to the rapid pace of life in Taiwan, England has a sophisticated, relaxed quality, as if to the British a hectic pace is less urbane and cultured. Then there is the famous British "reserved" attitude, exemplified by my British friends who often assert, "We're not conservative, just reserved." It is this kind of approach that allows England to stride along at its own pace, instead of following anxiously other nations. The UK's stance on joining the European Community is a case in point, as Britain was content to wait and see for a while before making its decision. Such conduct is an excellent illustration of the unique British deliberateness and prudence, qualities that also form a large part of Taiwanese impressions and visions of Britain.

Not long ago, when communications technology was not as advanced as today and distant travel was not as frequent, people developed particular impressions and fascination with distant places "over there." These images and expectations resulting from cultural differences and physical distance have resulted in stereotypes and exoticism, or negative descriptions based on shallow perception of other cultures. In the past, use of the word "exotic" to describe images and expectations of other cultures was fairly negative, whereas today, under the influence of globalism, we are attempting to share exoticism, thus lending the term more positive connotations. To be sure, exoticism is the unavoidable and understandable result of human nature, but what truly matters is whether such imagination and expectation can deliver deeper cultural sharing, exchange, and harmony, rather than remaining on the surface. The recent popularity in the West of the Taiwanese-produced film *Crouching Tiger, Hidden Dragon* is a good example of how people are always looking for new or different things. Often, when exotic places become a mirror in which to look upon ourselves, they also provide opportunities for dialogue with and reflection upon ourselves. As a medium of communication, art is first appreciated for its form, after which it is interpreted for its "story." The story is essential, encompassing the content of the work and the background behind its creation, compelling the viewer to examine his own cultural and social conditions accordingly. In this way, interpretation is taken beyond outward form to realize the objective of cultural exchange.

Sculpture in Britain

Field Dayi (for a detailed discussion of this phrase, see Lewis Biggs's essay) aims to explore the visualization, changing forms, and expanding concepts of British sculpture from 1960 to 2001 . In the development of modern British art, modern sculpture has elicited the highest regard on the international art scene, also boasting the most complete and robust line of development. As early as the Victorian age, Britain had a fine outdoor sculpture tradition. A costly and immortal method was chosen to demonstrate the British Empire's tremendous power and wealth: a large volume of outdoor public sculpture was commissioned for developing cities, thereby setting the foundation of England's fine sculpture tradition and establishing a strong association with the British Empire. Since the modern English sculptor Henry Moore, Britain has enjoyed a rich supply of sculpture talent highly regarded on the international stage, each generation making a special contribution to the evolution and development of the formal concepts of this art.

It is entirely appropriate to hold an exhibition selected to represent important developments in British sculpture from the latter half of the twentieth century. The reasons for this are complex, not only because of Britain's existing sculpture tradition, but also due to the English penchant for serious debate, engaging in continuous deliberation over any given issue. As schools and classrooms usually provide the best forums for debate, since the 1960s the development of British sculpture has been closely connected with several London art institutes and the continued attention of teacher-artists. Such circumstances are far less likely to exist in the United States or elsewhere in Europe. Although the realm of sculpture has expanded by constantly exceeding others, constant discussion of sculpture has become an additional "tradition" in its own right within the British art community (Britain also being very tradition-conscious), thereby reaping the collective fruits of several generations of sculpture.

The 1960s was a time of heated debate in England over the definition of sculpture. Such sculptors as Anthony Caro led the way to greater expansion of the abstraction of sculpture, and the cultivation of the next generation of young artists. After Caro, the efforts of wave upon wave of young sculptors from the 1960s through the 1980s greatly expanded the territory of sculpture, so that the works of numerous sculptors were no longer just "free-standing objects" but presented as two-dimensional photography,

text, computer output, videos, or even live performance. At the same time, broader attention to materials and processes became evident. Moreover, by the 1980s sculptors were less interested in the pure aesthetic expression of sculpture, but concerned rather with "all-encompassing" artistic creation, in hopes that sculpture offered broader connotations and allow exploration of a greater diversity of topics from politics and society.

The Poetic Ambience of British Sculpture

The development of British sculpture is so rich and diverse that rough categorization or labeling to encapsulate its cultural and artistic personality is sorely inappropriate. However, given different settings and audiences, modern British sculpture is invariably able to demonstrate the collective stylistic features of lyricism and tranquility. This tranquility is conducive to rumination, which in turn allows dialogue. Meanwhile, lyricism provides greater room for imagination. The "poetic objects" of the 1980s "new British sculpture" generation best represent this quality and can be gleaned in this exhibition from the works of , Tony Cragg, Anish Kapoor, Richard Deacon, Richard Wentworth, Bill Woodrow , and Antony Gormley. Going back further, the 1960s sculpture of Anthony Caro and Phillip King both share this quality. The lyricism generated by the distinctive colours, smooth surfaces and buoyant structures of Caro's sculptures has been carried forward in the works of several generations of artists since that time. Phillip King has stated the prime importance of colors to him. These subtle collective features are closely related to the British concern with man and nature (yet another tradition), distinguishing their development from that of other regions.

While British sculpture in the 1990s achieved greater diversity, the attention given to Rachel Whiteread, while due in no small part to the strength of her creative concept, at the same time illustrates Britain abiding infatuation with lyrical sculpture, as free-standing sculpture remains in the mainstream. The sculptures she has cast evoke a surreal deja vu feeling and pure tranquility. Her cast objects enable people to discover that the unique qualities and sculptural characteristics of traditional "monuments" still remain-or perhaps more aptly have "returned."

Compared to other Western nations (especially the United States), the traditional British respect for humanity and nature gives British sculpture greater leeway with which to approach "people." As such, the size of sculpture is related to the size of man, thus making it humanistic rather than absolute, and completely free of flamboyance. One finds that perhaps for such reasons Britain is relatively free of impressively large sculptures. This exhibition includes several ingenious small-scale works, such as Richard Deacon's Art for Other People and Bill Woodrow's small objects. Although we were unable to include the works of Ian Hamilton-Finlay, David Nash, or Hamish Fulton directly related to nature, including only Richard Long's work in this category, to a certain degree it can be said that modern British sculpture is generally connected to nature. For example, British sculpture is often noted for its distinguishing "groundedness," standing directly on the ground, the "natural" result of the development of twentieth century sculpture (sculpture coming down from its pedestal). This often leads viewers to associate these works with the earth or the ground, such as in the work of Tony Cragg, who arranges objects found in urban settings (in contrast to nature), evoking clear associations with the earth by the way they seem to hug the ground. It is important to note that in such works, the distinction between the earth and nature, as the discourse between nature and the city (the opposite of nature) becomes the earth or the existential environment in a broader sense.

The Extension of Everyday Objects

If we allow that the development of British sculpture from the 1960s through the 1980s represents the extension of traditional sculpture and the process of sculptural visualization, then the 1990s can be said to represent the extension and reconnection of everyday objects across various fields. The generation of "young British artists" that emerged from the *Freeze* exhibition curated by Damien Hirst won considerable critical acclaim worldwide. In addition to curator Hirst, this exhibition includes Freeze artists Michael Landy, Sarah Lucas, Anya Gallaccio and Mat Collishaw. Despite different content and concerns, these artists often appropriate found objects, placing common objects on the pedestal of art in an effort to give them certain deeper implications and eliminating the division between art and life. Furthermore, their works have expanded the concept of found objects to the formation of "company"-like systems, such as Michael Landy's *Scrapheap Services*. In 1990s sculpture, one finds extreme and extremely individual artistic expression; whether in the form of criticism of politics or consumer society, as a whole it appears more cheerful, optimistic, and bright than the art of previous generations. Part of an

international trend, it is one of the effects of globalization.

British Rebellion and Decadence

British art often storms onto the international art scene with rebellious performances attributable to the explosiveness of British art. The most direct associations that come to mind include the music of the Beatles or the contemporary film *Trainspotting*. Often such rebellious performances are challenges to current authorities or mores, and as such may also display certain perversion or decadence. Since the late 1960s, Gilbert and George have conveyed a certain British rebelliousness. Their "singing sculptures" completely liberated sculpture, echoing Joseph Beuys' concept of "man (everyone) as sculpture." This concept mingles with British theatre culture, gentlemanly style and humour, achieving major breakthroughs in the language of contemporary sculpture and assimilating traditional local culture. Jake and Dinos Chapman, for their part, set out to make their viewers thoroughly disgusted. Their nude, demonic, multi-headed youths, an acerbic response to the bizarre state of contemporary society, caused a stir when exhibited and attracted the censure of the moral guard. Far from an isolated case in Britain, their work is part of a continuum. For instance, the multi-headed nude youths remind me of the coloured figurative sculptures of Reg Butler in the 1970s. Other artists such as Damien Hirst with his preserved animal biopsies have naturally attracted widespread discussion throughout British society. I am reminded by these examples of photographs seen in England: parents in traditional attire posing together without conflict under the same roof with their outrageously punk son. This to me is a metaphor for respecting differences worthy of great pride.

The De-objectification of Sculpture

When sculpture is captured on video, documentary film, or in written word and exhibited, it is transformed into image in two dimensions. When viewers experience images hung on the wall in an exhibition space, such as the everyday light bulbs, rulers, globes, or chairs painted or taped on the wall by Michael Craig-Martin; are captivated by the intensely body-oriented films produced by Douglas Gordon; or appreciate the de-materialized rainbows of Anya Gallaccio; real objects are transformed into images, pictures, and concepts. What is sculpture? Perhaps it is just a response emphasizing differences with painting, just an image in the mind's eye, objects in relation to humans as subjects... or perhaps simply images in the "mirror"

reminding us of our existence.

Autonomy Via Distance and Intimacy

As an island nation, Britain has maintained a certain distance from the European continent, allowing it to develop its own distinctive politics, economics, culture, and art. On many levels, modern British sculpture reveals the unique aesthetic focus characteristic of this island nation: distance, one of Britain's unique aesthetic symbols. Distance can be generated in many ways. In terms of individual expression, the bright, smooth surfaces of Anthony Caro's sculptures suppress viewers' urge to reach out and touch them, creating distance between them and the sculpture. In contrast, the powdery textures of Anish Kapoor's works trigger the urge to touch, so that warnings such as "do not touch" or "prohibited" create distance. Damien Hirst uses a variety of "glass vitrines" to separate people (the audience) and his works. Other than this aspect, his most controversial works featured animal cross sections floating in preservatives within the boxes, causing unease and shocking visual effects. This work itself seems to mark distance. Richard Long, for whom "distance" seems to become part of his works in his exhibition of maps, photography and related material concerning specific places, uses a highly secretive creative process in which only the artist himself is involved. The great privacy and intimacy of his works create an acute sense of distance and autonomy. Distance generates autonomy; distance encompasses time and space. And this distance, both real and imagined, can be vast or small.

Dialogue - Eliminating Distance

"Distance" forms both the subject, and the space for imagination of the subject/object relationship. This aesthetic focus provides this exhibition with an interesting metaphor: the "distance" between Taiwan and Britain provides the Taiwanese viewing public an "exotic" mirror image against which to reflect on its own existence and state. Especially since Taiwan has not undergone the development process that Britain has experienced in modern sculpture, this exhibition offers both sides a chance for dialogue. When viewers regard the exhibited works, subject and object can become one through dialogue, eliminating all distance.

藝術家作品與簡歷 / 圖版

Colour plates and Artists' Biographies

作品尺寸：長 x 寬 x 高　公分, dimensions Height x Width x Depth in cms

安東尼・卡羅
ANTHONY CARO b.1924

卡羅出生於英國南部瑟瑞州新莫登市，1942-44年就讀於
基督學院工程系。1945-46年服務於皇家海軍快速部隊。
1946-47年他在倫敦麗晶街綜合技術學院(Regent Street
Polytechnic)學習雕塑。1951-53年任亨利・摩爾（Henry
Moore）的兼職助手。五〇年代早期授課於聖馬丁藝術學
校，1963-74年他的教學法啟發了兩代年輕藝術家，菲利
浦・金、貝瑞・佛拉納格、理查・龍、紀伯與喬治都是他
的學生。1987年受封騎士爵位，2000年獲頒「功德獎」。

卡羅於五〇年代曾從事於傳統造型創作，1959年美國福
特基金會獎助金資助的美國之旅，改變他對創作的看法，
在素材方面由青銅轉為鋼材。他開始創作抽象的上彩雕
塑，此類雕塑無基底台座，故有它自己的空間。他的成就
是揚棄雕塑以外世界的物件或意象的干擾，尤其是人的形
象。1961年的「雕塑之七」作品與1963年的「五月」作
品，都是這時期鮮明上色的經典之作，此二件作品均收羅
於1963年倫敦「白教堂畫廊」(Whitechapel Gallery)的第
一次個展中。七〇年代早期他不再於作品上上彩，使素材
本身的性質更為凸顯並闡明雕塑形式，雖然他先後嘗試
鉛、青銅、木頭、陶土及鋁等材質創作，但鋼材仍是他主
要使用的材質。

1957年，卡羅的第一次個展在米蘭市的那維里葛利歐畫廊
(Galleriadel Naviliglio)展出，次年他的第一次倫敦市個展
在金佩費爾斯(Gimpel Fils)展出。1966年他的作品於威尼
斯雙年展的英國館展出；1969年參展聖保羅雙年展，在這
兩次的展覽中他均獲獎項。1969年他的第一次回顧展於
倫敦海伍德畫廊(Hayward Gallery)展出，第二次回顧展是
四年之後在紐約現代美術館展出。1992年在羅馬的創居
市場(Trajar's Market)舉辦回顧展。1995年東京現代美術
館也為他舉辦大型回顧展。在九〇年代卡羅嘗試陶土創
作，因而有兩系列的陶土雕塑作品展覽：1994年「特洛伊
戰爭」展(The Trojan War)於倫敦展出，稍後於1997年巡
迴到雅典及施薩隆尼奇市(Thessaloniki)。1999年，第四
十八屆威尼斯雙年展展出其作品「最後審判」(The Last
Judgement)。他的作品散見於國際重要收藏之中，生活及
工作重心均在倫敦市。

Caro was born in New Malden, Surrey and read engineering at Christ's College Cambridge 1942-44. He served two years in the Fleet Air Arm of the Royal Navy before enrolling at the Regent Street Polytechnic, London where he studied sculpture 1946-47, and then at the Royal Academy Schools, London from 1947-50. From 1951-53 he worked as a part-time assistant to Henry Moore. He taught at St Martin's School of Art, London in the early 1950s and again from 1963-74 when his teaching methods became a catalyst for two generations of younger artists: Phillip King, Barry Flanagan, Richard Long, and Gilbert & George were among his students. He was knighted in 1987 and awarded the Order of Merit in 2000.

Caro had been working in a figurative tradition during the 1950s, but following his first visit to the USA with a grant from the Ford Foundation in 1959, he changed his materials from bronze to steel. He began to make abstract coloured sculptures which were independent of base or pedestal so that they inhabited their own space. His achievement was to rid sculpture of any associations with objects and images from the outside world, in particular the human figure. *Sculpture Seven*, 1961 and *Month of May, 1963*, are key examples of his brightly painted work of this period and both were included in his first major solo exhibition of the steel sculptures at the Whitechapel Art Gallery, London in 1963. He stopped using colour in the early 1970s, to allow the properties of the material itself to become more dominant and assert the power of the sculptural form, and though he has worked with lead, bronze, wood, ceramic clay and aluminium, steel has remained his primary material.

Caro had his first solo exhibition at the Galleria del Naviliglio, Milan in 1957 and his first show in London the following year at Gimpel Fils. His work was shown in the British Pavilion at the 1966 Venice Biennale and at the Sao Paulo Bienal in 1969, he was a prize winner on both occasions. His first retrospective exhibition was in 1969 at the Hayward Gallery, London and his second was four years later at the Museum of Modern Art, New York. In 1992 a retrospective exhibition was mounted in Trajan's Markets in Rome, and a major retrospective was organised by the Museum of Contemporary Art, Tokyo in 1995. Two large series of sculptures grew out of his immediate contact with ceramic clay in the 1990s; *The Trojan War*, shown first in London in 1994 and later in Athens and Thessaloniki in 1997, and *The Last Judgement*, shown at the XLVIII Venice Biennale in 1999. His work is included in major international collections. He lives and works in London.

Further reading

William Rubin: *Anthony Caro*, The Museum of Modern Art, New York, 1975

Seiji Oshima, Tadayasu Sakai, Yasuyoshi Saito: *Anthony Caro*, Museum of Contemporary Art, Tokyo, 1995

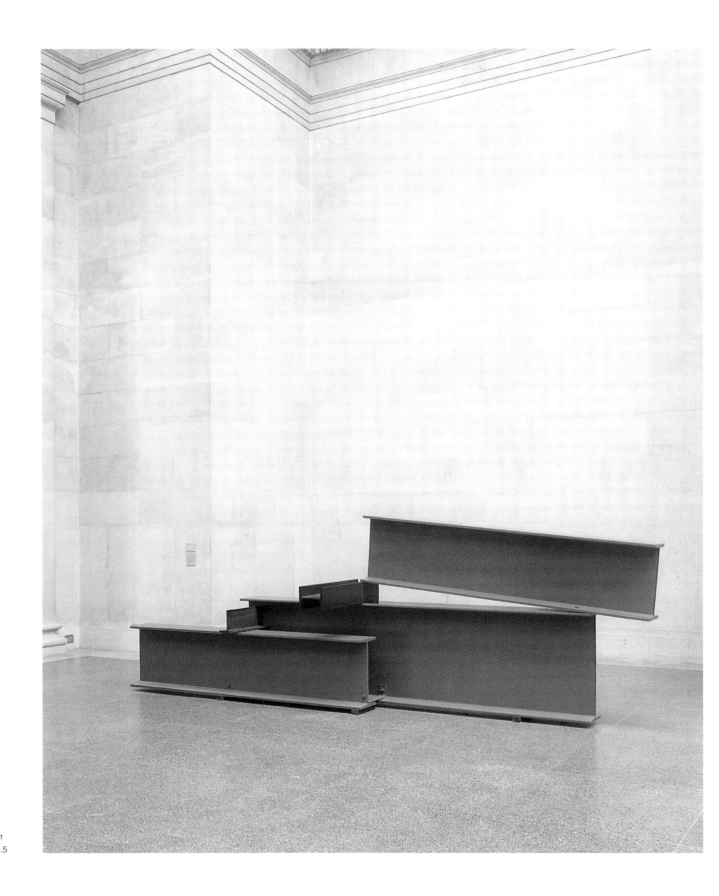

雕塑之七 1961
Sculpture Seven
178 x 537 x 105.5

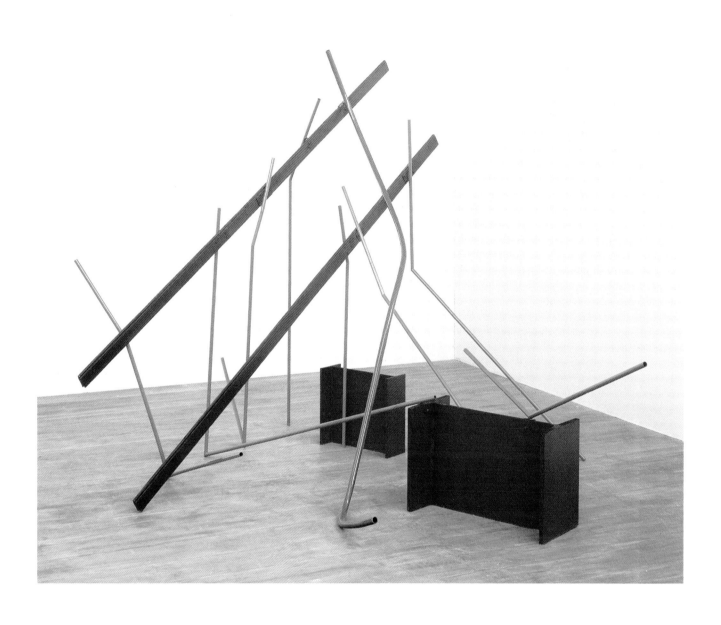

五月 1963
Month of May
279.5 x 305 x 358.5

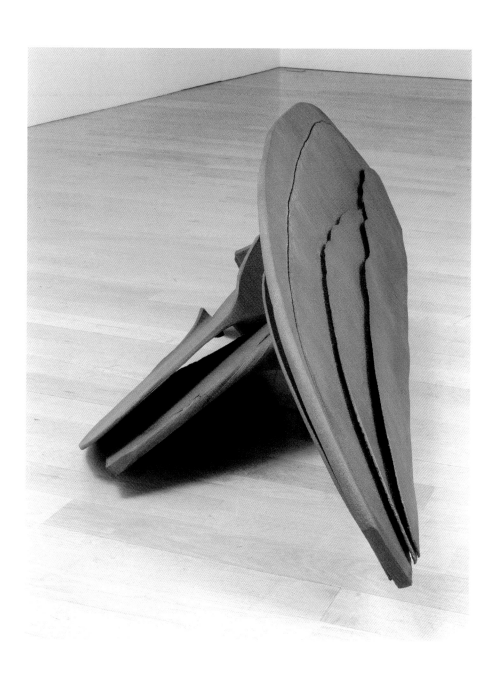

鼓翼 1976
Flap
63.5 x 75 x 198

菲利浦・金
PHILLIP KING b. 1934

金出生於突尼斯迦太基附近的卡錫爾丁（Kheredine）。
1946年抵達英國。1953-54年，他花了一年時間在巴黎
從事國家服務的事情。1954-57年，於劍橋基督學院研習
現代語言，同時，他也開始從事雕塑創作。1957-58年
間，就讀於安東尼・卡羅教學所在的聖馬丁藝術學校。由
1959-1978期間他開始授課於聖馬丁藝術學校。1959-60
年，他擔任亨利・摩爾的助手。1979-80年擔任柏林肯斯
特學院的雕塑教授。1980-90年，擔任倫敦皇家藝術學院
的雕塑教授。1974年接受C.B.E.勳章(英帝國司令勳章，
C.B.E.為Commander of British Empire之縮寫)。1990年
被選為皇家藝術學院院士，並於同年當選皇家藝術學院的
名譽教授；2000年當選皇家藝術學院院長。

1960年金在一趟希臘之旅後，開始從事抽象作品創作，
是英國第一批使用玻璃纖維為媒材的雕塑家之一。他的作
品事物不為人所見的層面，也就是「藏匿於表像之後，無
法為人所見的內在行逕。」他用顏色來刻畫他的作品，顏
色對他而言，是進入無法看見的世界的生命線，在此世界
中「感情取代理智操控了無法看見的世界，若缺乏藝術真
實性的認知經驗，便將虛浮而迅速消失殆盡。」1989
年，他又回頭創作造型雕塑，但仍持續努力於抽象的主題
創作。

1957年，金還是學生時便在劍橋海佛斯畫廊(Heffers
Gallery)舉行第一次個展。1964年，羅旺畫廊(Rowan
Gallery)為他舉行第一次的倫敦市個展，二年之後他的第
一次紐約個展在理查・芬畫廊(Richard Feigen Gallery)展
出。1968年，倫敦白教堂畫廊(Whitechapel Gallery)為他
舉辦了一大型個展，同年與布吉特・瑞利(Bridget Riley)共
同代表英國參加第三十四屆威尼斯雙年展；1997年在佛
羅倫斯的佛提地白雷德意(Fortidi Belredere)舉行一次主要
的作品回顧展。他參加過無數次的聯展，例如1965年白
教堂畫廊「新一代」展；1966年紐約猶太美術館「主結
構：新一代美國與英國雕塑家」展；1968年卡塞爾市「第
四屆文件大展」；1996年，巴黎國家網球場藝廊(Jeu de
Paume)的「英國雕塑新世紀」展。他在倫敦市工作、生
活，作品列入國際重要收藏。

King was born Kheredine, near Carthage in Tunis, and came to
England in 1946. Following National Service, he spent a year in
Paris 1953-54. He read modern languages at Christ's College,
Cambridge, 1954-57, and during this time started to make
sculpture. He then studied at St Martin's School of Art,London
1957-58, where Anthony Caro was teaching, and in 1959 he
began teaching at St Martin's himself and was to do so until
1978. He worked as an assistant to Henry Moore 1959-60.
From 1979-80 he was Professor of Sculpture at the Hochschule
der Kunste, Berlin and Professor of Sculpture at the Royal
College of Art, London 1980-90. He received the CBE in 1974,
was elected a Royal Academician in 1990 and made Professor
Emeritus at the Royal College of Art in the same year. He was
elected President of the Royal Academy of Arts in 2000.

King began to make abstract works after a visit to Greece in
1960, and he was amongst the first British sculptors to use
fibreglass as a medium. His work addresses the unseen
aspects of things, "the internal invisible goings-on behind the
surface". King's work has been characterised by his use of
colour which he sees as the life-line into the invisible world
"where feeling takes over from thinking and without the
experience of which one's sense of reality in art would be false
and diminished". He returned to making figurative sculpture in
1989 but has continued to make work on abstract themes.

King had his first solo exhibition in 1957 at Heffers Gallery,
Cambridge while he was still a student. His first solo exhibition
in London was at the Rowan Gallery in 1964 and his first solo
show in New York at the Richard Feigen Gallery two years later.
He had a large-scale solo exhibition at the Whitechapel Art
Gallery, London in 1968 and represented Britain (with Bridget
Riley) at the XXXIV Venice Biennale in the same year. A major
retrospective of his work was mounted at the Forti di Belvedere
in Florence in 1997. King's work has been included in
innumerable group exhibitions including *The New Generation* at
the Whitechapel Art Gallery, 1965, *Primary Structures: Younger
American and British Sculptors* at the Jewish Museum, New
York, 1966; *Documenta IV*, Kassel, 1968 and *Un Siècle de
Sculpture Anglaise* at the galerie nationale du Jeu de Paume,
Paris, 1996. His work is included in major international
collections. King lives and works in London.

Further reading

Tim Hilton: *The Sculpture of Phillip King*, The Henry Moore
Foundation in association with Lund Humphries, London 1992

Giovanni Carendente, Bryan Robertson, Richard Cork: *Phillip
King*, Electa, Milan, 1997

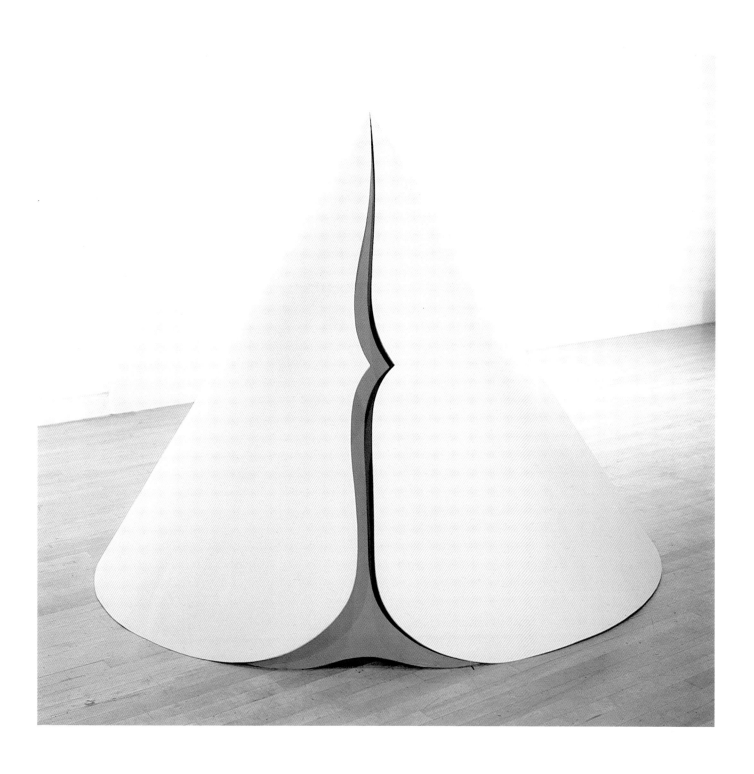

玫瑰花苞， 1962
Rosebud
153x 183 x183

漣漪，1963
Ripple
188 x 89 x 77

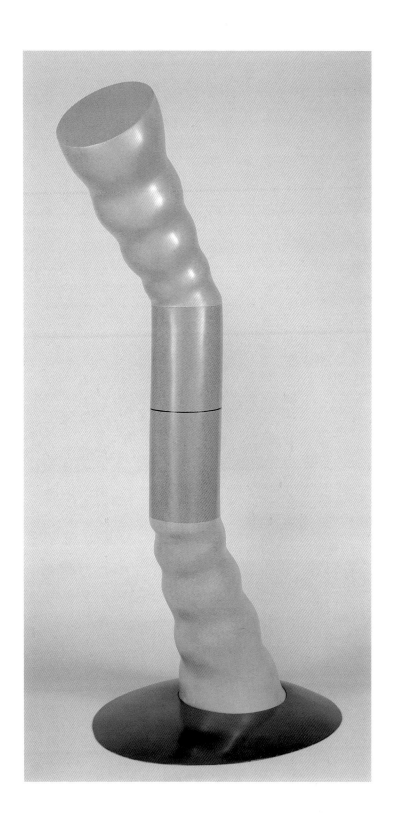

愛德華 • 包羅契
EDUARDO PAOLOZZI b.1924

包羅契出生於愛丁堡的列詩市(Leith)。1940-43年服務於先鋒公司；1944-47年先後就讀於牛津魯斯金藝術學院與倫敦的史萊德藝術學院。1947年首展於倫敦市長畫廊(Mayor Gallery)，當時他還是一個學生；他藉著作品所得到巴黎，居住了二年。曾授課於英國、德國、美國的藝術學校，1981-91年擔任慕尼黑造形藝術學院的雕塑教授。包羅契在1986年受任為女皇的蘇格蘭在地雕塑家。1989年並受封騎士爵位。

1952年，包羅契是「獨立集團」(Independent Group)的共同創始人，該集團對大眾傳播與戰後世紀的科技發展特別有興趣。包羅契此時的雕塑，是鑄銅的圖騰式機械時代的人像。1952年第二十六屆威尼斯雙年展，他的作品出現在英國館的「英國雕塑新貌」；1957年在第四屆聖保羅雙年展的「十位年輕英國雕塑家」中展出，並於南美洲巡迴。第三十屆威尼斯雙年展，他代表大不列顛展出回顧展，因此獲頒大衛布萊特基金會獎章（45歲以下）最佳雕塑家。

在接下來的十年內，包羅契的作品結合工業技術。大部分以鋁材製作，再塗上鮮明的色彩或鉻黃色。1971年倫敦泰德美術館為其舉辦回顧展；1994年約克郡雕塑公園舉辦一雕塑與畫展慶祝他的七十大壽。包羅契接了許多公共計畫案，例如倫敦市蹕亭漢路(Tottenham)地下車站中的陶製壁畫；另一件是位於倫敦新大英圖書館的一件青銅雕塑，名為「布雷克之後的牛頓」。一件最大的經典之作現由1999年開幕的國立蘇格蘭畫廊收藏。包羅契居住、工作於倫敦。

Paolozzi was born in Leith, Edinburgh. He served with the Pioneer Corps, 1940-43 and studied at the Ruskin School of Art, Oxford and then the Slade School of Fine Art, London, 1944-47. He had his first solo exhibition at the Mayor Gallery, London in 1947 whilst still a student and with the proceeds of sales went to Paris where he lived for two years. He has taught in art schools in the United Kingdom, Germany and the USA and was Professor of Sculpture at the Akadamie der Bildenden Kunst, Munich from 1981-1991. Paolozzi was appointed Her Majesty's Sculptor-in-Ordinary for Scotland in 1986 and was knighted in 1989.

In 1952 Paolozzi was co-founder of the Independent Group which had a particular interest in mass media and the new developments in science and technology in the post-war era. Paolozzi's sculptures of this period were totemic machine-age figures cast in bronze. In 1952 he was included in the exhibition *New Aspects of British Sculpture* shown at the British Pavilion for the XXVI Venice Biennale, and in 1957 his work was shown in the exhibition *Ten Young British Sculptors* at the IV São Paulo Bienal and tour of South America. He represented Britain again at the XXX Venice Biennale with a retrospective exhibition, for which he was awarded the David E Bright Foundation Award for the Best Sculptor under 45.

His work of the following decade incorporated industrial techniques and was mostly executed in aluminium and brightly painted or finished in polished chrome. He had a retrospective at the Tate Gallery, London in 1971 and an exhibition of sculpture and graphics was mounted by the Yorkshire Sculpture Park in 1994 to celebrate his 70th birthday. Paolozzi has undertaken many commissions including the ceramic wall murals in Tottenham Court Road Underground Station, London and a large bronze sculpture, *Newton after Blake*, for the new British Library in London. The largest comprehensive collection of Paolozzi's work is now housed in the National Galleries of Scotland Dean Centre which opened in 1999. Palozzi lives and works in London.

Further reading

Diane Kirkpatrick: *Eduardo Paolozzi*, Studio Vista, London, 1970

Fiona Pearson: *Paolozzi*, National Galleries of Scotland, Edinburgh, 1999

Eduardo Paolozzi Writings and Interviews, edited by Robin Spencer, Oxford University Press, 2000

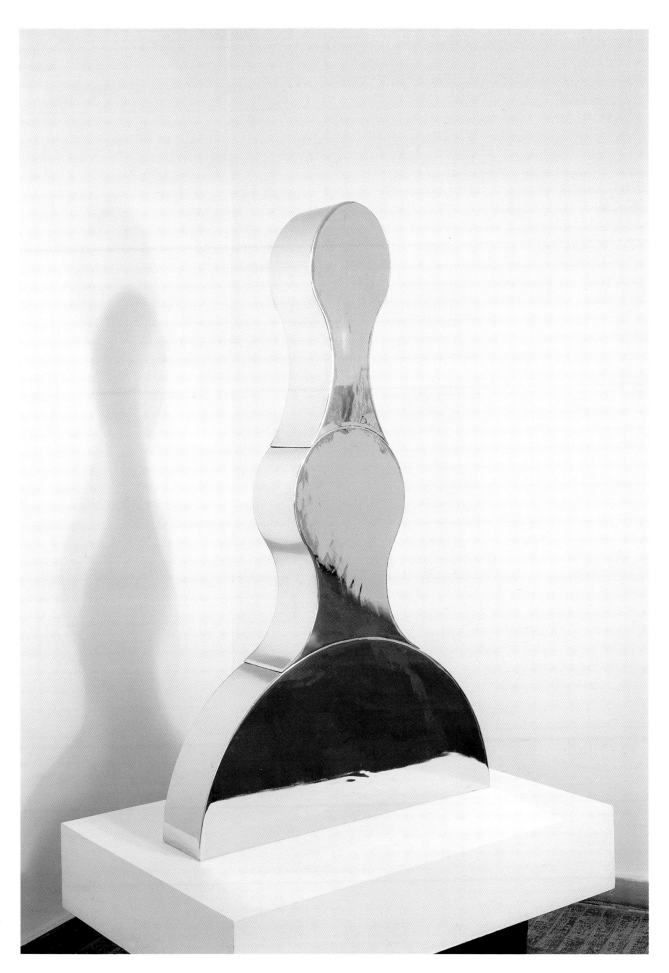

杜勒斯之一， 1967
Dollus I
131 x 79 x 16

四座塔，1963
Four Towers
203.2 x 77.5 x 78.4

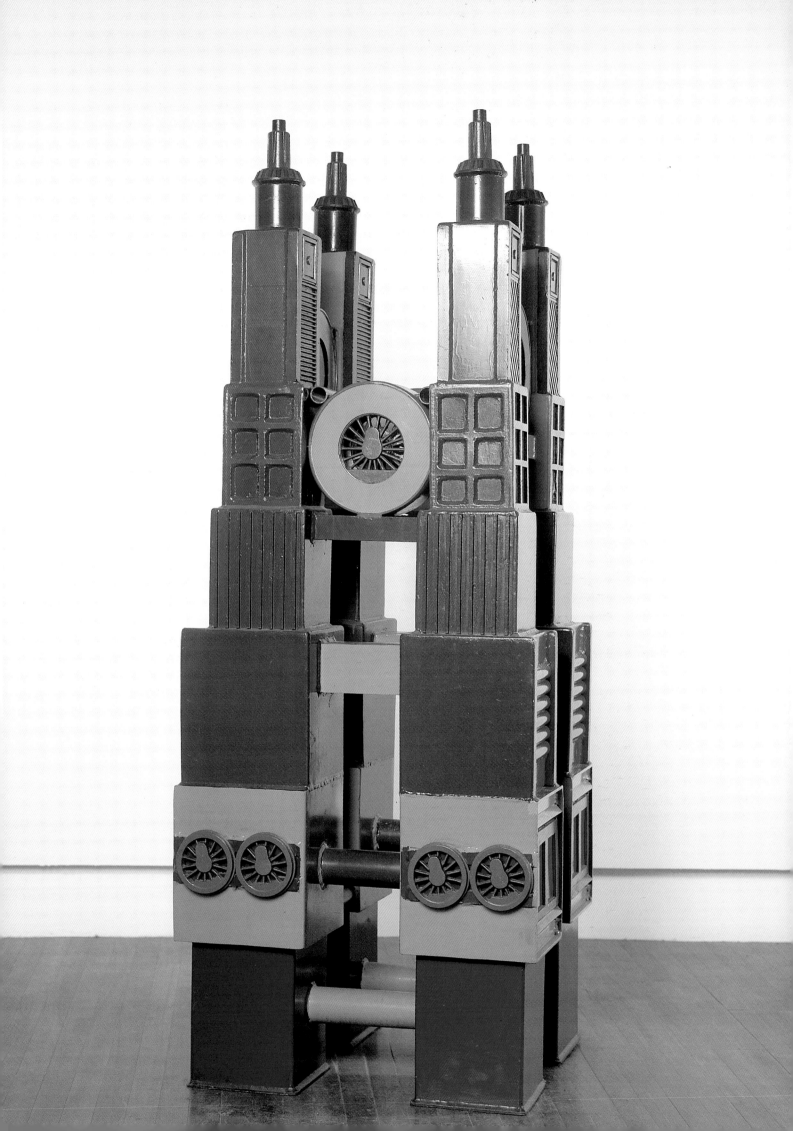

貝瑞・佛拉納格
BARRY FLANAGAN b. 1941

佛拉納格生於英國北威爾斯布里斯達丁市(Prestatyn)。曾就讀於伯明罕工藝學院。1964年就讀倫敦聖馬丁藝術學校,當時安東尼・卡羅為任課教師之一;佛拉納格後來在1967-71年間執教於該校。1987年他被選為皇家藝術學院的會員。

六〇年代佛拉納格利用最質樸的素材如沙、麻布、亞麻布、繩等,製作一組實驗性雕塑而聲名大噪。這組作品始做於聖馬丁藝術學院,是對當時校內雕塑主要素材--鋼鐵的一種反動。佛拉納格作品的標誌是利用有造形的布袋,裝滿沙或其他乾的材料,如此一來,這些沙或乾材給予作品一股柔軟、有機的形式,反映著輕靈的觸感,結合著處理材質的巧思與細膩情感。整個七〇年代,他以一些較傳統的材質創作,如石頭、大理石與鋼。1979年他開始使用青銅並做了一系列動物作品,有關野兔的主題特別多見。

1966年,佛拉納格的第一次個展在倫敦羅旺畫廊(Rowan Gallery)舉行。1977年第一次回顧展於尹德哈芬市(Eindhoven)泛艾伯美術館(Van Abbemuseum)展出。1982年他代表英國在第四十屆威尼斯雙年展展出,此展隨後巡迴到克理費爾德市(Krefeld)的浩斯伊斯特斯美術館(Museum Haus Esters)及「白教堂畫廊」中展出。1993年馬德里的蓋薩基金會(la Caixa)與英國文化協會共同舉辦個人回顧展,此展後來巡迴到南特市(Nantes)。他曾參加過多次聯展:1969年,瑞士伯恩美術館「當態度成為形式」展;1987-88年美國芝加哥現代美術館「沈靜的革命:1965年以來的英國雕塑」展,此展並巡迴到其它地點展出。1993年,倫敦海伍德畫廊的「重力與優雅:1965-1975雕塑的改變條件」展。他的作品散見於國際重要收藏。佛拉納格生活、工作於都柏林市(Dublin)。

Flanagan was born in Prestatyn, North Wales. He studied at Birmingham College of Arts and Crafts and in 1964 he enrolled at St Martin's School of Art, London where the course tutor was Anthony Caro. He later taught at St Martin's from 1967-71. He was elected an Associate of the Royal Academy of Arts, London in 1987.

Flanagan made his reputation in the 1960s with a group of exploratory sculptures made with modest materials such as sand, hessian, flax and rope. This work began at St Martin's School of Art and was in part a reaction to the metal sculpture which was dominant in the school at that time. Cloth shapes were filled with sand or some other dry material which gave the resulting work a soft, organic form and reflected a lightness of touch combined with a keen sense of wit and feel for the materials that are the hallmarks of Flanagan's work. Throughout the 1970s he worked with more traditional materials such as stone, marble and steel. In 1979 he began using bronze in which he has made a long series of works, often using animals, in particular the hare.

Flanagan had his first solo exhibition at the Rowan Gallery, London in 1966 and his first retrospective exhibition at the Van Abbemuseum, Eindhoven in 1977. He represented Britain at the XL Venice Biennale in 1982 and the exhibition subsequently toured to the Museum Haus Esters, Krefeld and the Whitechapel Art Gallery, London. In 1993 a major retrospective of his work was organised by the Fundación "la Caixa", Madrid in collaboration with the British Council, which toured to the Musée des Beaux Arts de Nantes . He has been included in numerous group exhibitions including *When Attitudes Become Form* at Berne Kunsthalle in 1969, *The Quiet Revolution: British Sculpture Since 1965* at the Museum of Contemporary Art, Chicago and tour in 1987-88, and *Gravity and Grace: the Changing Condition of Sculpture 1965-1975* at the Hayward Gallery, London in 1993. His work is included in major international collections. Flanagan lives and works in Dublin.

Further reading

Catharine Lampert: *Barry Flanagan Sculpture 1966-1976*, Van Abbemuseum, Eindhoven, 1977

Tim Hilton, Michael Compton: *Barry Flanagan*, The British Council, 1982.

Enrique Juncosa, Jon Thompson: *Barry Flanagan* Fundacion "la Caixa", Madrid 1993

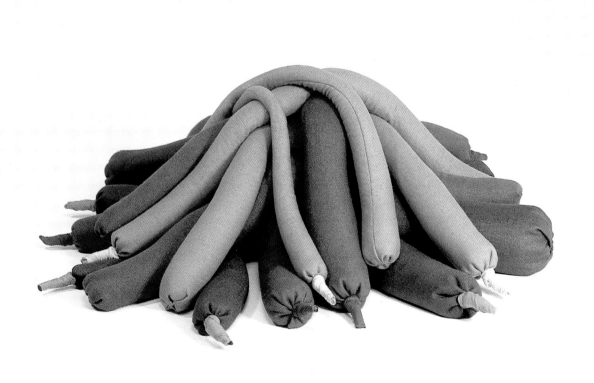

堆 第4號，1967
Heap 4
60 x 131 x 100

草印之一，1967-68
Grass print1
51 x 78

草印之二，1967-68
Grass print 2
51 x 78

草印之三， 1967-68
Grass print 3
51 x 78

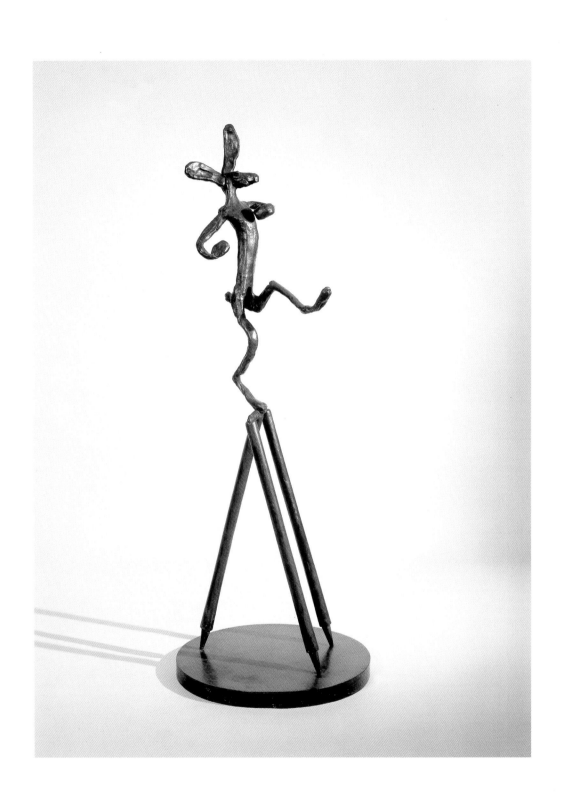

玩板球的人，1981
The Cricketer
156.2 x 39.3 x 53.4

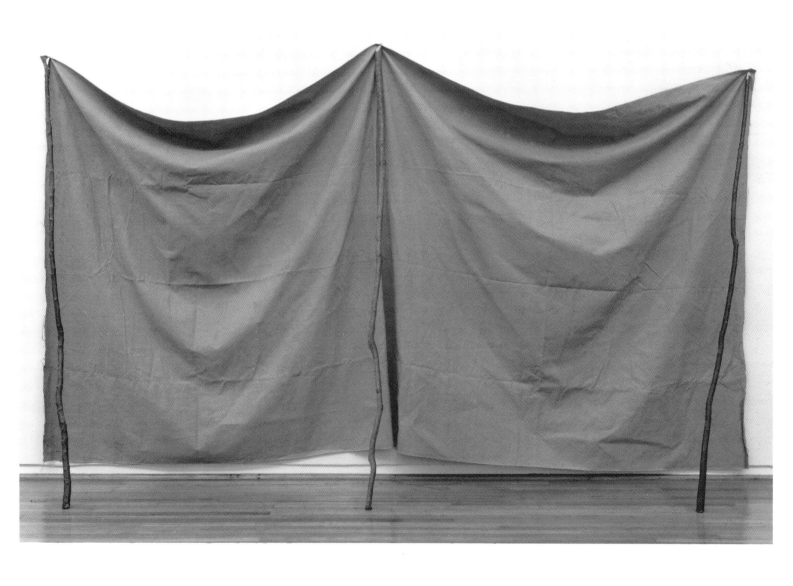

六九年六月（之二），1969
June (2) '69
292.1 x 508 x 88.9

紀伯與喬治
GILBERT & GEORGE b.1943 & b.1942

紀伯 1943 年生於義大利的白雲石市(Dolomites)，喬治 1942 年生於英國迪文市(Devon)。1967 年兩人於倫敦市 聖馬丁藝術學院結識後便居住、工作在一起，自此兩人都 一起發表呈現。1986 年兩人獲倫敦市泰德美術館頒「泰 納獎」。

在創作生涯的初期，他們以「活雕塑」的形象出現，通常 需保持他們自訂的姿勢數小時之久。除了這些持久性的表 演之外，他們也製作書籍作品、明信片雕塑，同時他們也 是錄影帶藝術的先驅。攝影逐漸成為他們的主要媒材；並 製造大型的牆上作品以其獨特觀點描述人性的各種面向。 早期攝影作品的顏色侷限於黑與白，或再搭配另一種顏 色，通常是紅色；但自八○年代早期，他們開始嘗試製作 超大尺寸的作品，引進較飽和的色彩，引發如彩繪玻璃上 宗教圖像般的象徵力量。

1986 年，他們的第一次個展是在倫敦法蘭克三明治酒吧 (Frank's Sandwich Bar)舉行，此後便廣泛地展出。紀伯與 喬治也在世界各地美術館做大型個展：例如 1980 於尹德 哈芬(Eindhoven)；1987 及 1933 年於倫敦；1990 年於莫 斯科；1993 年於北京及上海1997於東京、巴黎；1999年 於瓦倫西雅(Valencia)。倫敦是兩人主要的居住及工作地 點。

Gilbert was born in the Dolomites, Italy and George in Devon, England. They met in 1967 at St Martin's School of Art, London, and have lived and worked together presenting themselves as a single entity ever since. They were awarded the Turner Prize at the Tate Gallery, London in 1986.

At the beginning of their careers Gilbert and George appeared as 'living sculptures', in which they adopted poses lasting for several hours. In addition to these durational performances, they made book works, postcard sculptures and were early pioneers of video art. Photography gradually became their main medium and they produced large wall based works depicting their unique vision on all aspects of human nature. The colour of the early photographic work was limited to black and white, or with one other colour, most commonly red, but since the early 1980s they have worked on a heroic scale and introduced a more saturated field of colour, evoking the emblematic power of religious iconography in stained glass .

Their first solo exhibition was in 1968 at Frank's Sandwich Bar, London and they have been exhibited widely ever since. They have had major solo museum shows throughout the world, including Eindhoven, 1980, London, 1987 and 1993, Moscow, 1990, Beijing and Shanghai, 1993, Tokyo, 1997, Paris, 1997 and Valencia 1999. Gilbert and George live and work in London.

Further reading

Carter Ratcliffe: *Gilbert and George 1968 to 1980*, Municipal Van Abbemuseum, Eindhoven, 1980

Wolf Jahn, *The Art of Gilbert & George*, Thames and Hudson Limited, London, 1989

Beatrice Parent, Bernard Marcade, Wolf Jahn, Rudi Fuchs, an interview with Martin Gayford and texts by Gilbert and George:*Gilbert and George*, Musée d'Art Moderne de la Ville de Paris, Paris, 1997

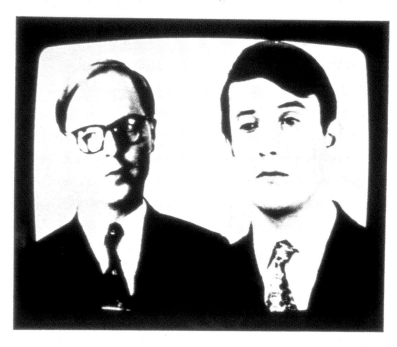

"A PORTRAIT OF THE ARTISTS AS YOUNG MEN"

Summer 1972

Sculpture on Video Tape

NO. 7 OF 25

This tape should be viewed with
'high contrast' as in this photograph

George and Gilbert
the sculptors

'ART FOR ALL' 12 Fournier Street London E1
01-247 0161

如青年般的藝術家肖像， 1972
A Portrait of the Artists as Young Men

"GORDON'S MAKES US DRUNK"

Summer 1972

Sculpture on Video Tape

NO. 6 OF 25

George and Gilbert
the sculptors

'ART FOR ALL' 12 Fournier Street London E1
01-247 0161

戈登的店使我們喝醉，1972
Gordon's Makes us Drunk

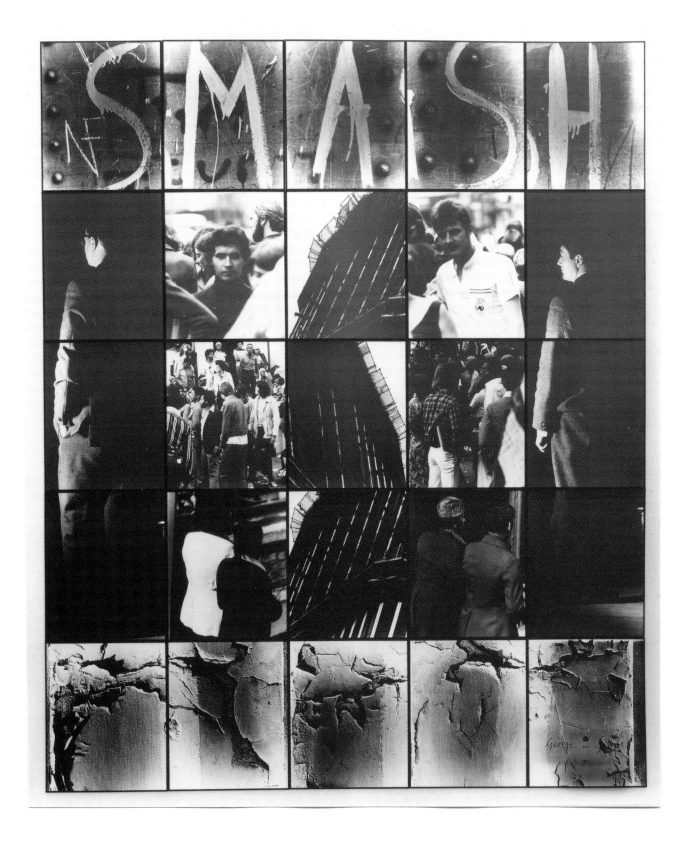

粉碎， 1977
Smash
302.5 x 252.5

理查‧龍
RICHARD LONG b.1945

龍生於布里斯托市(Bristol)。1962-65年就讀於西英國藝術學院，1966-68年就讀於聖馬丁藝術學院於1988獲頒「阿亨藝術獎，新美術館－路德維收藏」(Kunstpreis Aachen, Neue Galerie-Sammlung Ludwig)，1989年獲倫敦泰德美術館頒「泰納獎」，1990年獲法國政府頒藝術文學騎士獎章。

雖然龍的作品融入了英國傳統的地景，但他似乎與貧窮藝術的「簡約、質樸的方法和過程」，或觀念藝術中強調「觀念的重要性」較為相近。他的作品，被表現在「行走」於偏遠荒涼幽靜的地景中，使雕塑延伸並加入時間的過程，再以攝影、文字或地圖等記錄。走路時他沿途採集、發現不同的物質來製作其地景雕塑，或展示於藝廊中，他曾說：「我關注簡單意象的情感力量。」並將這些素材安排成圓形或線狀的、「互久不變的，普遍的，可瞭解的，容易製造的」的圖形。

1968年，他舉辦第一次個展於杜塞道夫的孔拉德費雪畫廊(Galerie Konrad Fischer)之後便更廣泛展出。1976年受邀參加第二十二屆聖保羅雙年展。1986年及1991年分別於紐約古根漢美術館(Guggenheim Museum)及倫敦海伍德畫廊(Hayward Gallery)展出。他的作品廣為世界公家機構典藏。理查‧龍居住、工作於英國西部。

Long was born in Bristol. He studied at the West of England College of Art, 1962-65, and at St Martin's School of Art, London from 1966-68. He was awarded the Kunstpreis Aachen, Neue Galerie-Sammlung Ludwig in 1988, the Turner Prize at the Tate Gallery, London in 1989, and was named the Chevalier dans l'Ordre des Arts et des Lettres by the French Government in 1990.

Although Long works within an English tradition of landscape, his sympathies are closer to Arte Povera "simple, modest means and procedures" or Conceptual Art "the importance of ideas". His work, expressed in walks through remote and uncluttered landscapes, has led to an extension of sculpture to include the passage of time and this takes form in photographic, text and map works. In addition to which he collects various materials found en route to produce work both within the landscape itself and in galleries. Long has said, "I am interested in the emotional power of simple images," and the materials which he finds are arranged in configurations such as circles and lines, which are "timeless, universal, understandable and easy to make."

Long had his first solo exhibition at Galerie Konrad Fischer, Düsseldorf in 1968 and has continued to exhibit widely since. In 1976 he represented Britain with a solo exhibition at the XXXVII Venice Biennale and in 1994 he was invited to participate in the 22nd São Paulo Bienal. Major exhibitions of his work have been mounted at the Guggenheim Museum, New York in 1986 and the Hayward Gallery, London in 1991. His work is included in public collections worldwide. Long lives and works in the West of England.

Further reading

R.H.Fuchs: *Richard Long*, Solomon R Guggenheim Museum, New York and Thames and Hudson Limited, London, 1986

Anne Seymour, an interview with Richard Cork: *Richard Long*; Walking in Circles, The South Bank Centre, London, 1991

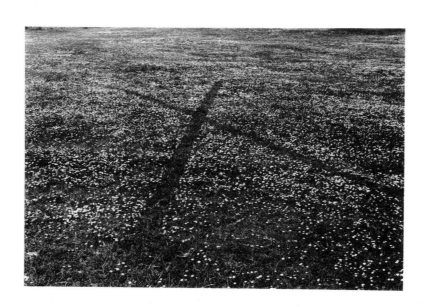

英格蘭， 1968
England
83.8 x114.3

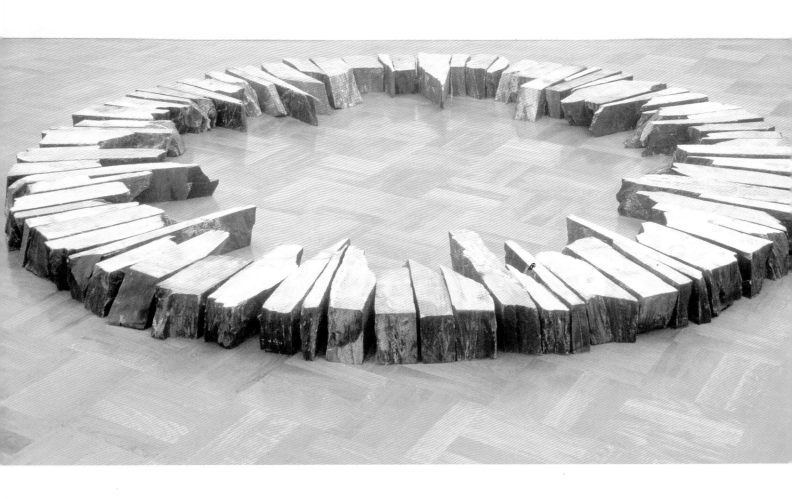

春天之圓， 1992
Spring Circle
直徑 diameter 300

THREE MOORS THREE CIRCLES

A 108 MILE WALK FROM BODMIN MOOR, TO DARTMOOR, TO EXMOOR,
WALKING AROUND THREE CIRCLES ALONG THE WAY
LISKEARD TO PORLOCK ENGLAND 1982

三處荒野三個圓，1982
Three Moors Three Circles
106 x 164

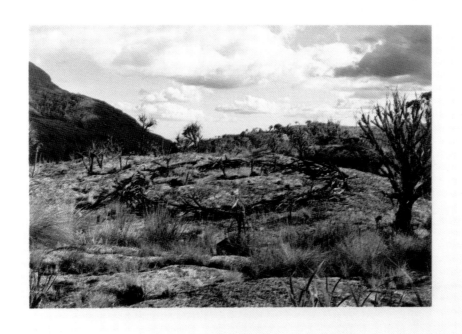

非洲之圓，1978
Circle in Africa
83.8 x114.3

麥克・克雷格-馬丁
MICHAEL CRAIG-MARTIN b. 1941

克雷格-馬丁生於愛爾蘭的都柏林市,他家後來搬到倫敦繼而搬到美國。於1961-63年就讀康州新天堂市耶魯大學的耶魯學院,1964-66年以「研究生後」(post graduate)身份回到英國。1966年接受了英國西部貝斯藝術學院(Bath Academy of Art)的教職,並居住在該地,1968年搬回倫敦市居住。1970-72年擔任劍橋國王學院(King's College)駐校藝術家。1973-83年任教於倫敦大學哥德史密斯學院。1994年被委任為美術教授。

三十多年來,克雷格-馬丁發展出一種描繪人造物品,特別是國產用品意象的特殊語彙。他減少物品的色度、質感、實體感,主要為線條與平面化的圖形,將我們熟悉的物品置於一個陌生的新環境中,予以再次呈現。最近克雷格-馬丁曾說到他第一次觀賞極限主義藝術家們的作品,如羅伯特・莫里斯(Robert Morris)、唐納・賈德(Donald Judd)、卡爾・安德(Carl Andre)、以及索爾・李維特(Sol Lewitt)等人的作品。他說:「雖然他們的作品是『抽象』,我卻被寫實主義所震憾,他們強調空間、尺寸、實體性等直接的實體經驗。對我而言是導入一種開發真實物品本性與功用的觀念,這種觀念自那時起便是我創作的基礎。」

1969年,他第一次個展於倫敦羅旺畫廊(Rowan Gallery)展出,並持續定期於該畫廊展出直到七六年底。1976-77年間「麥克・克雷格-馬丁1966-75作品選集展」巡迴英國、蘇格蘭、威爾斯等地六家畫廊。1989年他的主要回顧展於倫敦市「白教堂畫廊」展出。1982年他代表英國參加第五屆印度三年展及1998年第二十四屆聖保羅雙年展。他的作品廣為歐美知名機構收藏。他居住、工作於倫敦。

Craig-Martin was born in Dublin, Ireland; his family later moved to London and then to the United States. He studied at Yale College, Yale University, New Haven, Connecticut, 1961-63, returning as a post-graduate 1964-66. He accepted the offer of a teaching post at Bath Academy of Art in the west of England in 1966, living locally before moving to London in 1968 . He was Artist-in-Residence at King's College, Cambridge, 1970-72. He taught full-time at Goldsmiths College of Art, University of London 1973-83 and was appointed Millard Professor of Fine Arts in 1994.

For over 30 years Craig-Martin has developed a vocabulary of images depicting man-made, mainly domestic objects. He reduces the material aspects of colour, texture and solidity to essential lines and planes and re-presents the familiar in an unfamiliar context. In a recent statement Craig-Martin referred to the first time he saw work by the American minimalists, Robert Morris, Donald Judd, Carl Andre and Sol Lewitt: "Although their work was apparantly 'abstract', I was struck by the 'realism' of its emphasis on direct and immediate physical experience of space, scale and materiality. This seemed to me to lead inevitably to the idea of exploring the nature and function of 'real' objects, an idea which has underlain my work ever since".

Craig-Martin had his first solo exhibition at the Rowan Gallery, London in 1969, where he continued to show regularly until 1976. An exhebition *Michael Craig-Martin Selected Works 1966-75*, toured to six galleries in England, Scotland and Wales in 1976-77, and a major retrospective of his work was shown at the Whitechapel Art Gallery, London in 1989. He represented Britain at the Fifth Indian Triennale in 1982 and the 24th Bienal São Paolo in 1998. His work is included in collections in Europe and the United States. Craig-Martin lives and works in London.

Further reading

Norbert Lynton: *Michael Craig-Martin*, Fifth Triennale India, The British Council, 1982

Lynne Cooke, an interview with Robert Rosenblum, selected writings by Michael Craig-Martin: *Michael Craig-Martin: A retrospective 1968-1989*, Whitechapel Art Gallery, London, 1989

（與天體一起）閱讀，1980
Reading (With Globe)
dimensions variable
尺寸視場地而定

湯尼·克雷格
TONY CRAGG b.1949

克雷格生於利物浦市(Liverpool)，於1968年接受正式的藝術教育。在此之前他是自然橡膠產品研究協會的實驗室技師。1973-1977年他先後就讀於溫布頓藝術學校的葛拉斯特藝術與設計學院，以及皇家藝術學院；在皇家藝術學院時結識理查·迪肯與比爾·伍德卓。1977年克雷格移居德國伍伯特市(Wuppertal)，並於1978年開始在杜塞道夫昆斯達卡(Kunstakademie)學院教書，於1988年獲得教授資格。1988年獲倫敦泰德美術館頒「泰納獎」。自1994年來，他一直是皇家學院的成員之一。

克雷格早期的塑膠作品，利用地板與牆面，建立材質、物體與意象等特殊語彙。他前所未有地使用都市及工業剩餘碎材，賦予新意，為雕塑開創一嶄新領域，克雷格稱此為「新自然」。他的雕塑自此以後不同凡響，且富於變化。他也處理運用各種不同的材質，例如：石頭、鑄鐵、青銅、玻璃以及鋁。

1979年，克雷格在倫敦里森藝廊舉辦第一次個展，從此他便持續地在該畫廊展出。1987年，他在倫敦的海伍德畫廊(Hayward Gallery)有一次重要的個展，1988年他代表英國參加第四十八屆威尼斯雙年展。他參加過許多重要的國際性展覽及委託案，近年經常在白教堂畫廊舉辦個展。他的作品見於國際重要收藏。克雷格居住於德國，工作重心也在德國。

Cragg was born in Liverpool. He worked as a laboratory technician at the Natural Rubber Producers Research Association before turning to formal art education in 1968. He studied at Gloucester College of Art and Design, Wimbledon School of Art and later at the Royal College of Art, London from 1973-1977, where he formed friendships with Richard Deacon and Bill Woodrow. In 1977 Cragg moved to Wuppertal, Germany. He started teaching at the Kunstakademie Düsseldorf in 1978 and received a professorship in 1988. He was awarded the Turner Prize at the Tate Gallery, London in 1988 and has been a member of the Royal Academy since 1994.

Cragg's early works in plastic established a vocabulary of materials, objects and images, using the floor and the wall. His innovative use of urban and industrial detritus was handled with an inventiveness which opened up a whole new territory for sculpture, dealing with an environment which Cragg called 'the new nature'. His body of sculpture since has been prodigious and diverse and he has worked with a wide range of materials such as stone, cast iron, bronze, glass, and aluminium.

Cragg had his first solo exhibition at the Lisson Gallery, London in 1979 and has continued to exhibit there regularly. He had a major solo exhibition at the Hayward Gallery, London in 1987, and in 1988 he represented Britain at the XLIII Venice Biennale. Many important international exhibitions and commissions have followed and in recent years he has had solo exhibitions at the Whitechapel Art Gallery, London and Tate Liverpool. His work is included in major international collections. Cragg lives and works in Germany.

Further reading

Lynne Cook: *Tony Cragg*, The Arts Council of Great Britain, 1987

Germano Celant: *Tony Cragg*, Thames and Hudson Limited, London, 1996

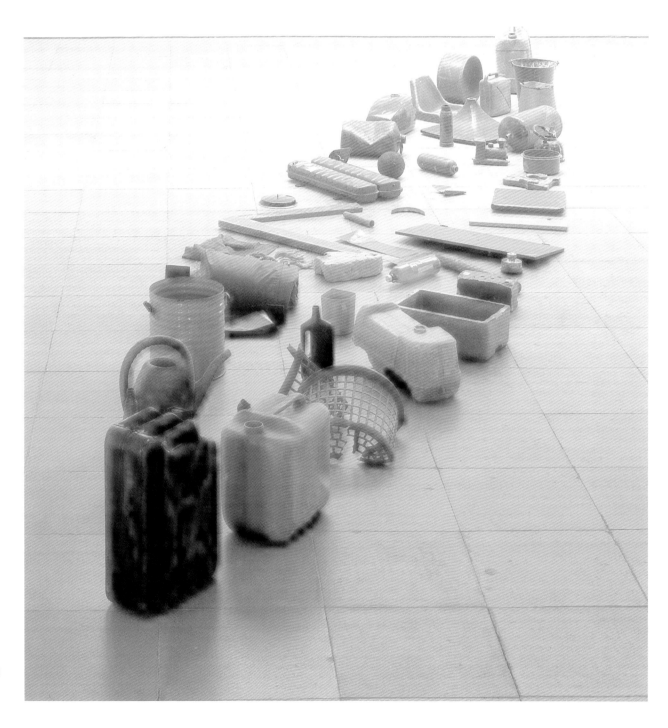

獨木舟, 1982
Canoe
長 length 800

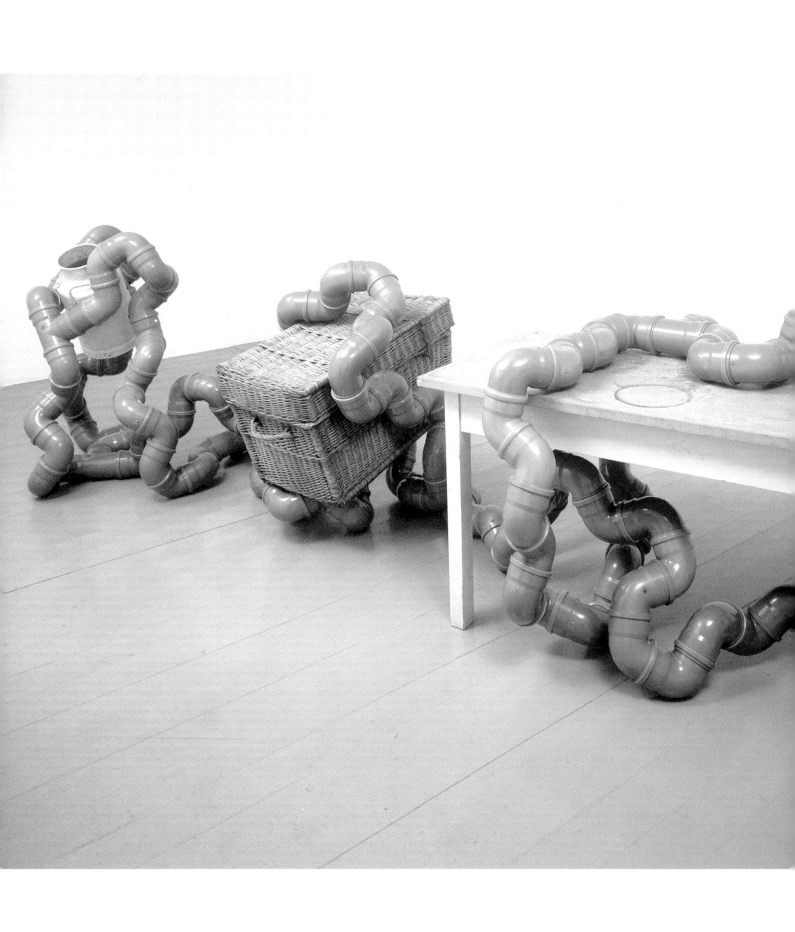

喬治與龍，1984
George and the Dragon
110 x 400 x 120

理查・迪肯
RICHARD DEACON b.1949

迪肯出生於北威爾斯班戈市(Bangor)，1969-1972年間，他就讀於聖馬丁藝術學院，1974-1977年就讀於倫敦皇家藝術學院。1978-79年，居住於紐約市並於該地工作。1987年獲泰德美術館頒「泰納獎」。1996年獲法國政府頒文學藝術騎士獎章。1999年，因為他對英國藝術卓越的貢獻而獲頒C.B.E.英帝國司令勳章。

八〇年代早期迪肯開始運用薄片木板，鍍鋅的鋼材，波狀鐵片及布料，油氈布等便捷而可即刻運用，沒有太多歷史包袱的素材來製作雕塑隆起及彎曲線條等形式；他的作品結合自然形式並帶有一種工業性的感知，範圍由室內規模的「為其他人而做的藝術」系列到巨大的公共委託計畫案。在過去二十年間，他一直走在英國現代雕塑發展的前端。

1975年，皇家藝術學院畫廊展出其第一次個展，1983年他第一次在里森畫廊展出，之後便定期在該畫廊展示新作。他也經常在國際藝壇上展出，並且受委託數起計畫案，例如：他是1999年北京所委託製作公共計畫案的第一位西方藝術家，他的作品廣為世界各公立機構收藏。迪肯居住在倫敦，並於該地從事藝術工作。

Deacon was born in Bangor, North Wales. He studied at St Martin's School of Art, London, 1969-1972, and later at the Royal College of Art, London, 1974-1977. In 1978-1979 he lived and worked in New York. He was awarded the Turner Prize at the Tate Gallery in 1987, the Chevalier dans l'Ordre des Arts et des Lettres by the French Government in 1996, and was made CBE for his significant contribution to the arts in Britain in 1999.

In the early 1980s Deacon began making sculpture which employed swelling, curvilinear forms made from laminated wood, galvanised steel, corrugated iron, cloth and linoleum; materials which were serviceable, readily to hand and not burdened with strong traditions or preconceptions. His works combine natural forms with an industrial sensibility and range from the domestic scale of the *Art for Other People* series to monumental public commissions. Over the last two decades he has remained at the forefront of developments in contemporary British sculpture.

Deacon had his first solo exhibition at the Royal College of Art Galleries in 1975 and his first solo show at the Lisson Gallery, London in 1983 where he has continued to exhibit since. He has exhibited internationally and received a number of international sculpture commissions including, in 1999, the first major public sculpture commission for a western artist in Beijing. His work is included in national and public collections worldwide. Deacon lives and works in London.

Further reading

Michael Newman: *Richard Deacon Sculpture 1980-1984*, The Fruitmarket Gallery, Edinburgh, 1984

Charles Harrison, Peter Schjeldahl: *Richard Deacon Sculptures and Drawings 1985-1988*, La Fundación Caja de Pensiones, Madrid

Jon Thompson, Peter Schjeldahl, Mary Douglas, an interview with Pier Luigi Tazzi, and selected writings by Richard Deacon: *Richard Deacon*, Phaidon Press Limited, London, 1995

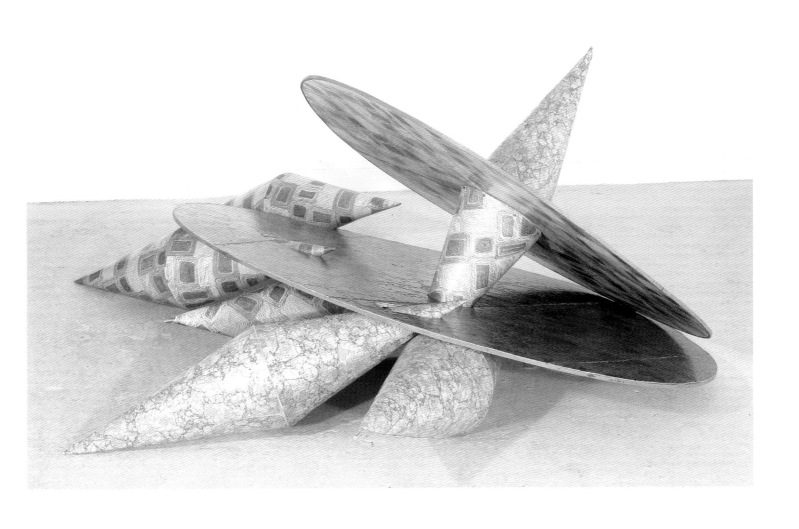

男孩與女孩（出來玩），1982
Boys and Girls (come out to play)
91.5 x 183 x 152.5

為其他人而做的藝術 第12號， 1984
Art for Other People n° 12
42 x 35 x 20

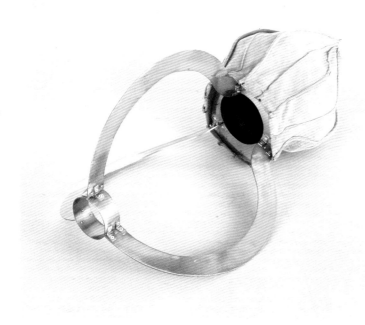

為其他人而做的藝術 第6號， 1983
Art for Other people n° 6
25 x 45 x 25

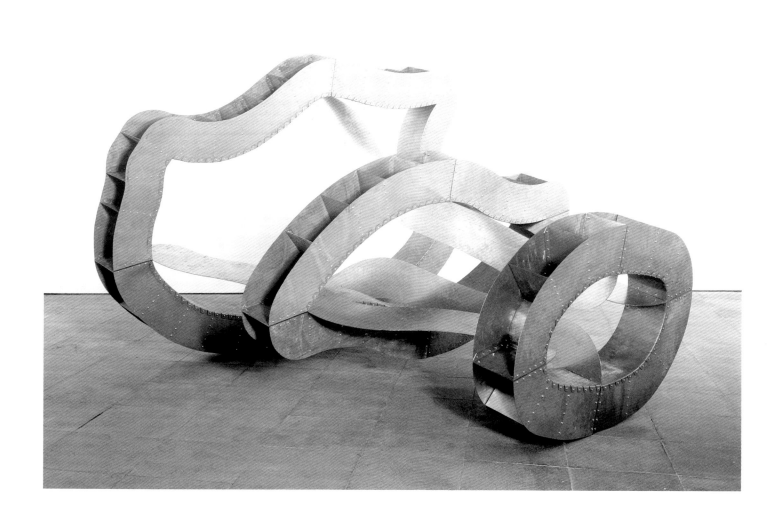

眼睛的饗宴，1987
Feast for the Eye
170 x 245 x 280

比爾·伍德卓
BILL WOODROW b. 1948

伍德卓出生於牛津郡泰唔士河畔的漢利附近。1967-68年就讀溫徹斯特藝術學校(Winchester School of Art)；1968-71年於倫敦聖馬丁藝術學校學習；1971-72年就讀於倫敦雀而喜藝術學校(Chelsea School of Art)。

伍德卓早期作品取材自日常物品，例如腳踏車或吸塵器，將物品嵌於石膏或水泥之中，再清除石膏或水泥中的部分物件，如此一來便類似於遠古化石或古生物的遺骸一般。其作品的特色與標誌是結合物質社會的物件及文化批評，賦予他們新的生命。1980年伍德卓開始回收洗衣機、冰箱與車體的金屬薄片來組構作品。各樣組件由原來的東西上拆卸下來，並用金屬的軸線連接著創造了新意象。

1972年，伍德卓第一次個展於倫敦「白教堂畫廊」展出，自此之後便做經常性的展出。愛丁堡「果市畫廊」於1986年策劃一項有關他作品的主要大展。1991年受邀展出於第二十一屆聖保羅雙年展。1996年，泰德美術館舉辦了一個展覽，後來巡迴到德國達姆斯達(Darmstadt)。伍德卓也承接辦理一些重要的委託案，他的作品被廣泛收藏。目前居住、工作於倫敦。

Woodrow was born near Henley-on-Thames, Oxfordshire. He studied at Winchester School of Art, 1967-68, St Martin's School of Art, London, 1968-71, and Chelsea School of Art, London, 1971-72.

Woodrow's early works were made from everyday objects, such as bicycles or vacuum cleaners, which were embedded in plaster or concrete and partially excavated, like fossils or archaeological remains. This combination of material goods and comment on the culture that gave them birth became a hallmark of his work. In the 1980s Woodrow began re-cycling and constructing works from the metal sheeting used in washing machines, refrigerators and car bodies. Various objects were cut from the original source but held to it by a metal umbilicus to create a new image.

Woodrow had his first solo exhibition in 1972 at the Whitechapel Art Gallery, London and has exhibited regularly since. The Fruitmarket Gallery, Edinburgh organised a major survey of his work in 1986 and in 1991 his work was included in the XXI Sao Paulo Bienal. The Tate Gallery mounted an exhibition in 1996 which travelled to Darmstadt in Germany. Woodrow has participated in numerous group exhibitions,including *Starlit Waters: British Sculpture and International Art 1968-1988*, at the Tate Gallery, Liverpool in 1988; *Un Siécle de Sculpture Anglaise* at the galerie national du Jeu de Paume, Paris, 1996; and *Material Culture: The Object in British Art of the 1980s and '90s* at the Hayward Gallery, London in 1997. He has undertaken a number of major commissions and his work is represented in collections worldwide. Woodrow lives and works in London.

Further reading

Lynne Cook: *Bill Woodrow Sculpture 1980-86*, The Fruitmarket Gallery, Edinburgh, 1986

John Roberts: *Bill Woodrow Fool's Gold*, Tate Gallery, London, 1996

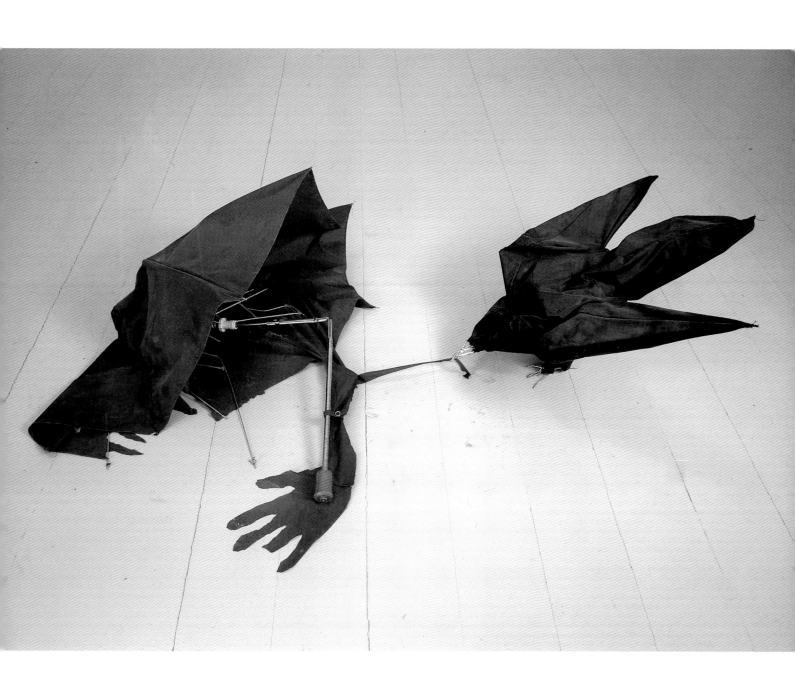

烏鴉與腐肉， 1981
Crow and Carrion
37 x 100 x 55

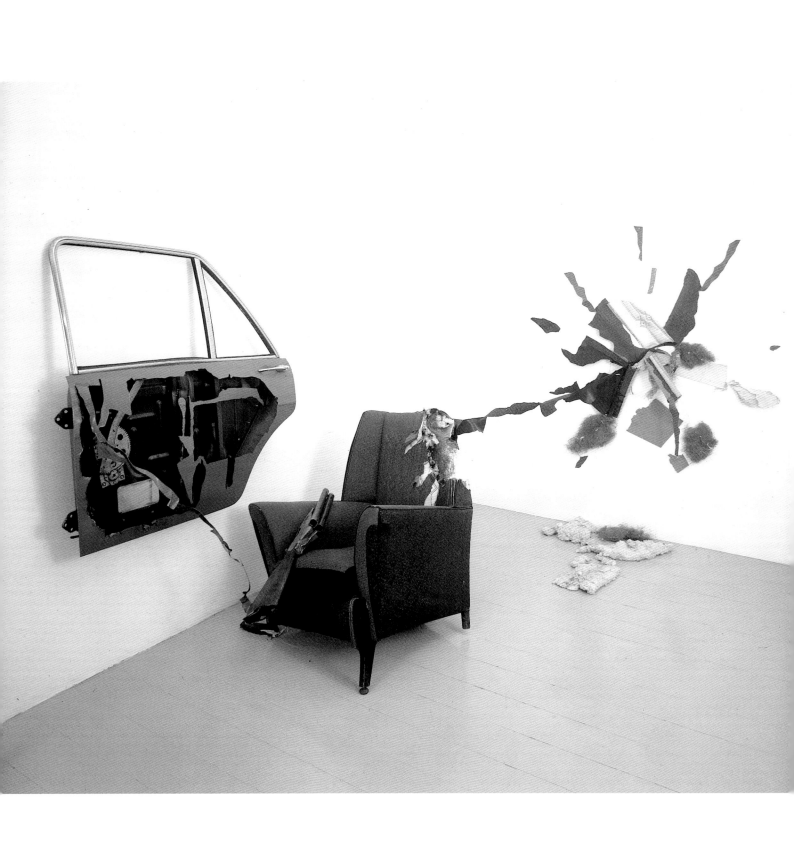

車門、扶手椅與意外，1981
Car Door, Armchair and Incident
120 x 300 x 300

電光火與黃色的魚，1981
Electric Fire with Yellow Fish
27 x 37 x 19

豆子罐頭與管子， 1981
Bean Can with pipe
11 x 12 x 15

照相機與蜥蜴， 1981
Camera and Lizard
19 x 27 x 13

玻璃罐, 1983
The Glass Jar
28 x 31 x 20

理查 ● 溫特渥斯
RICHARD WENTWORTH b. 1947

溫特渥斯出生在西南太平洋的薩莫爾島(Samoa)。1965年，就讀於倫敦宏斯藝術學院；1967年，在就讀皇家藝術學院之前，他擔任亨利●摩爾的助手。1974年，他得到馬可●洛詩科(Mark Rothko)紀念獎章；1975-78年在紐約居住及工作。他的教學生涯悠久，包括自1971-87年期間，在英國倫敦大學哥德史密斯學院教書；也參加了1993-94年柏林的DAAD藝術計畫案。

溫特渥斯的雕塑是專注在日常物品。他曾說過自己的作品：「我很努力地使作品如實呈現。」他花了好幾年的時間製作一系列攝影作品「將就使用也過得去」，記錄物品如被使用在不同用途上，與原來被製作使用的意圖大相逕庭。這「湊合著用」的主旨在其雕塑與攝影中結合了廣泛不同的物件，他借用了杜象的觀念，再次審視什麼是藝術，以及什麼是被稱為藝術的現成品。

1973年，他在倫敦格林威治劇院畫廊舉行第一次個展；1984年第一次在里森畫廊辦個展，爾後就不定期地在里森展出。1987年在紐約的個展於渥夫畫廊(Wolff Gallery)第一次展出。1994年瑟本泰畫廊為其舉辦了一次主要的回顧展；1997-98年德國弗萊堡藝術聯盟及哥屏根市立美術館為其舉辦展覽並巡迴展出。他的作品在多處大型聯展中出現，並被重要的公立及國家機構所收藏。

Wentworth was born in Samoa. He studied at Hornsey College of Art, London from 1965, and in 1967 he worked as an assistant to Henry Moore before enrolling at the Royal College of Art. In 1974 he received the Mark Rothko Memorial Award and lived and worked in New York in 1975 and 1978. He has taught extensively including a period at Goldsmiths College, University of London from 1971 to 1987. He participated in the DAAD Artists' Programme, Berlin, 1993-94.

Wentworth's sculpture has focused on the everyday object. He has said of his work: 'I try very hard to make my work appear matter-of-fact'. Over a number of years, he has worked on a photographic series *Making Do and Getting-By*, a record of how objects are used in ways different from their original intention. This 'making do' brings together a variety of objects, in his photography and sculpture, a redeployment of the Duchampian double-take on what is art and what is merely a ready-made to be called art.

Wentworth had his first solo exhibition at the Greenwich Theatre Gallery, London in 1973. He had his first solo exhibition at the Lisson Gallery in 1984 and has continued to exhibit there intermittently since. His first solo show in New York was at the Wolff Gallery in 1987. In 1994 the Serpentine Gallery mounted a major retrospective and an exhibition of his work for Germany was organised by and toured to Kunstverein Freiburg, Städtische Galerie Göppingen and Bonner Kunstverein in 1997-98. His work has been shown in numerous group exhibitions and is represented in major public and national collections.

Further reading

Marina Warner: *Richard Wentworth*, Thames and Hudson Ltd., in association with the Serpentine Gallery, London, 1993

Gregor Muir, Stephan Berg, Werner Meyer, and text by Richard Wentworth: *Richard Wentworth*, Kunstverein Freiburg im Marienbad, Städtische Galerie Göppingen, Bonner Kunstverein, 1997

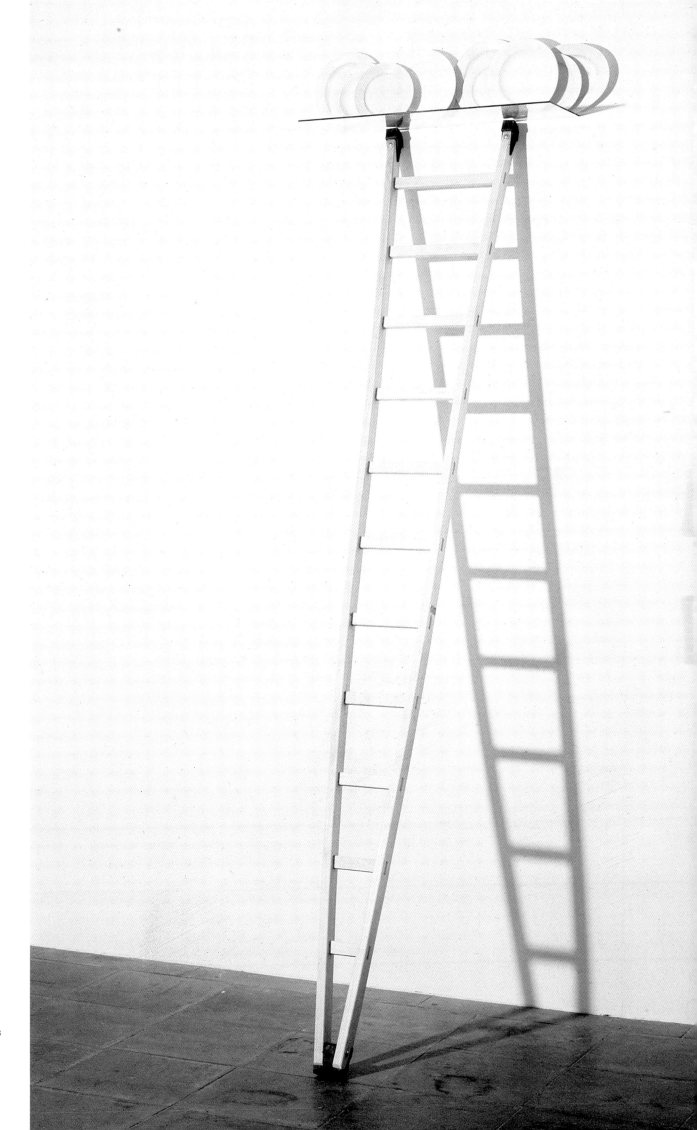

積雲，1991
Cumulus
320 x 90 x 23

玩具，1983
Toy
31 x 41 x 62.5

安東尼・貢利
ANTONY GORMLEY b. 1950

貢利生於倫敦。1968-71年，就讀於劍橋三一學院，修習
考古學、人類學及藝術史等課程；1974-75年，就讀於倫
敦中央藝術學院；1975-77年，於倫敦大學哥德史密斯學
院學習；1977-79年，就讀於倫敦大學史萊德美術學院；
1994年泰德美術館頒與「泰納獎」。

貢利的作品關心個體及群體與空間的關係。他廣泛地使用
不同材質，例如水泥、鐵、陶土，特別是鉛。鉛型雕塑是
他自身的鑄模，或站、或跪、或躺、或彎曲抱腿等。作品
最先是石膏打造，再經調整修飾，上一層玻璃纖維，最後
分區上鉛再焊接連成一體。他承接了數起公共雕塑的計畫
案，包括已成為英國東北區著名地標的「北方的天使」
(The Angel of the North)，廣大的鋼屹立於二十公尺高之
處，翼寬五十公尺。1990年他開始從事陶土人形的「田
野」(Field)裝置作品；陶土雕塑座落於澳洲、美洲、歐洲的
田野以及一處「英倫島田野」(Field for the British Isles)。

貢利的第一次個展於倫敦市瑟本泰畫廊(Serpentine
Gallery)展出，以及1981年於「白教堂畫廊」展出，並持
續在世界各地展出。1993-94年間，愛爾蘭現代美術館與
泰德美術館駐利物浦分館聯合舉辦他的大型個展。他的作
品為世界重要收藏單位收藏。貢利目前居住、工作於倫敦
市。

Gormley was born in London. He read archeology,
anthropology and art history at Trinity College,
Cambridge, 1968-71, studied at the Central School of
Art, London 1974-75, Goldsmiths School of Art,
University of London, 1975-77 and Slade School of Fine
Art, University of London, 1977-79. He was awarded
the Turner Prize for 1994 at the Tate Gallery, London.

Gormley's work is concerned with the body and the
relation of mass to space. He works with a variety of
materials including concrete, iron, terracotta and, most
significantly, lead. The lead figure sculptures are
moulds of his own body, standing, kneeling, lying,
crouching. They are taken first in plaster, adjusted,
refined and coated in fibreglass, the lead is then added
in sections and soldered. He has undertaken numerous
public sculpture commissions including what has now
become a famous landmark in the north-east of
England, *The Angel of the North*, a vast winged figure in
Corten steel standing 20 metres high with a wing span
of 50 metres. In 1990 he embarked on the first of his
Field installations of terracotta figures; there are in all
Fields for Australia, America, Europe and a *Field for the
British Isles*.

Gormley had his first solo exhibitions in London at the
Serpentine Gallery and the Whitechapel Art Gallery in
1981 and has continued to exhibit regularly worldwide.
He had a major solo exhibition organised jointly by
Konsthall Malmö, Tate Gallery Liverpool and the Irish
Museum of Modern Art, 1993-1994. His work is in major
public international collections. Gormley lives and
works in London.

Further reading

Lewis Biggs, Stephen Bann, an interview with Declan
McGonagle: *Antony Gormley*, Tate Gallery, Liverpool,
1993

John Hutchinson, Lela B Njatin, an interview with E.H.
Gombrich, an interview with Declan McGonagle and
selected writings by Anthony Gormley: *Antony Gormley*,
Phaidon Press Limited, London, 1995

在此世界之外 1983-84
Out of this World
130 x 120 x 90

馬勒維奇的角落， 1992
Corner for Kasimir
193 x 162 x 100

安尼許 • 克普爾
ANISH KAPOOR b.1954

克普爾生於龐貝城(Bombay)。1973-77年,他就讀於倫敦宏斯藝術學院(Hornsey College of Art);1977-78年,就讀於雀而喜藝術學校(Chelsea School of Art)。他是1982年利物浦渥克藝廊(Walker Gallery)的駐館藝術家;1991年獲泰德美術館頒泰納獎。

1979年,克普爾訪問出生地印度之後,便開始在雕塑創作中使用粉末狀的顏料。最早的粉末雕塑是由顏料與粉筆構成;但當作品後來加進木頭、玻璃纖維、石膏等支撐材質,雕塑形狀呈現出含有植物及礦物等成分。近年,他更廣泛地使用各項材質,例如沙岩、大理石、水泥、鐵及鋼等。藍色顏料在克普爾作品中佔有特殊的地位,他曾說那是「靈魂出竅」的顏色,這是為什麼此一顏色的象徵本質一直存在其作品中成為主導力量。

1980年在巴黎帕帝斯亞歷山大(Patrice Alexander)展出其第一次畫室個展。1982年倫敦里森畫廊(Lisson Gallery)首展,代表英國參加第四十四屆威尼斯雙年展,並獲得杜米拉首獎(Premio Duemila)。1998年海伍德畫廊舉辦他的主要作品展。他參與了不少重要聯展,並承接許多重要委託計畫案,例如2000年倫敦市千禧巨蛋新雕塑方案中的「喻言水」(Parabolic Waters)作品。他的作品被收藏於世界各重要典藏中。克普爾居住及工作重心均於倫敦市。

Kapoor was born in Bombay. He studied at Hornsey College of Art, London, 1973-77, and at Chelsea School of Art, 1977-78. He was Artist-in-Residence at the Walker Art Gallery, Liverpool in 1982 and was awarded the Turner Prize at the Tate Gallery in 1991.

Kapoor's use of powdered pigment colour in sculpture followed a visit to his native India in 1979. The earliest powder sculptures were composed of pigment and chalk, but as the works developed a basic support of wood, fibreglass or plaster was introduced, the shapes of the sculptures suggesting plant and mineral forms. In more recent years he has worked with a wide variety of materials including sandstone, marble, concrete, iron and steel. Blue pigment has a special position in Kapoor's work, he has said it is the colour of that 'which is disembodied', and it is this symbolic nature of colour which has continued to be a driving force in his work.

Kapoor had his first solo studio show at Patrice Alexander, Paris in 1980 and his first exhibition at the Lisson Gallery, London was in 1982. He represented Britain at the XLIV Venice Biennale where he was awarded the 'Premio Duemila' prize. In 1998 a major exhibition of his his work was organised by the Hayward Gallery, London. He has participated in numerous important group exhibitions and has undertaken a number of major commissions including *Parabolic Waters* for the Millenium Dome New Sculpture Project, London in 2000. His work is represented in major collections worldwide. Kapoor lives and works in London.

Further reading

Germano Celant: *Anish Kapoor*, Charta, Milan, 1995

Homi K Bhabha, Pier Luigi Tazzi: *Anish Kapoor*, Hayward Gallery, London and University of California Press, 1998

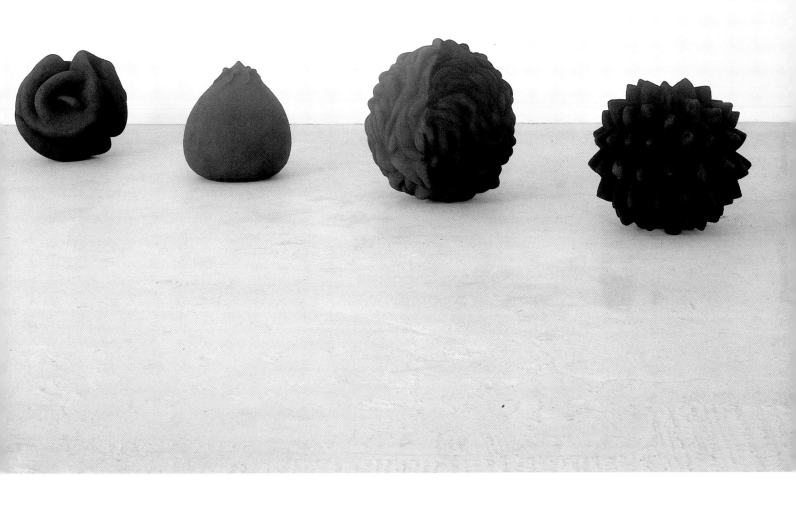

藍色的讚美詩， 1983
The Chant of Blue
三件: 61 x 61 x 61
一件: 76 x 76 x 76

虛空， 1994
Void
直徑 diameter 110

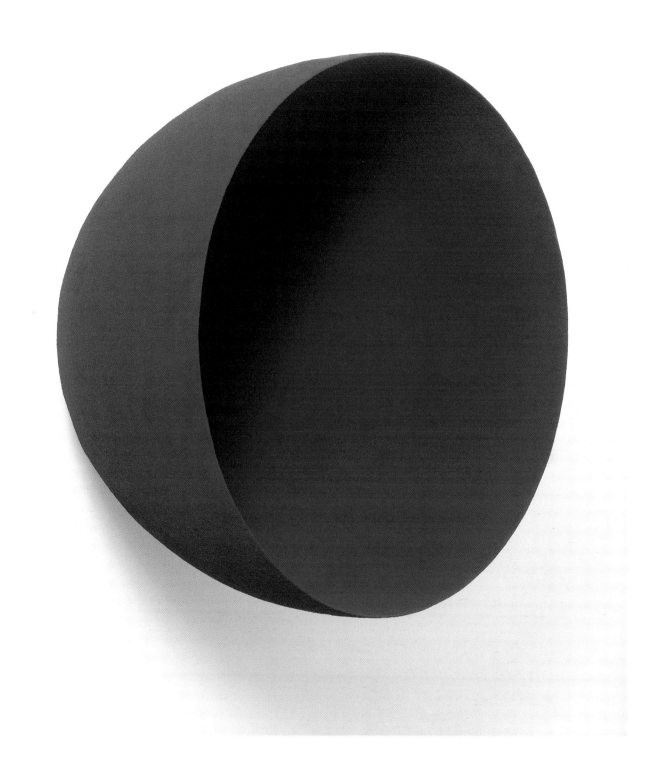

蒙娜・哈同
MONA HATOUM b. 1952

哈同生於黎巴嫩的貝魯特市，於1970-72年就讀於貝魯特大學。1975年來到倫敦，黎巴嫩隨即發生戰爭，她只好流亡國外。1975-79年，就讀於倫敦拜恩修藝術學校(Byam Shaw School of Art)，1979-81年就讀於史萊德藝術學院。

哈同最當初以表演工作聞名，八〇年代後期她開始利用錄影與音效等從事雕塑和環境裝置作品。監視的主題與身份認同的問題都反覆地在作品中出現。1989年她的「末端的燈光」裝置作品於倫敦「展示間畫廊」(Showroom Gallery)展出，利用六件電熱物體垂直懸於金屬樑架上，整個空間類似一個幽暗的通道，這件作品基於人性對吸引及排拒兩種矛盾情續而創造，當觀眾被燈光吸引而趨近作品時又會因散發的高溫而退卻三步；這件作品後來於1990年「英國藝術」巡迴展中展出。她早在1980年便有「陌生的軀體」的想法，但這件作品直到1994年在巴黎龐畢度中心的個展中才被實現。作品是圓柱體的構造，影片投射於地上，播出內視鏡攝影鏡頭在藝術家的身體內所經歷的旅程，同時伴隨著擴大音效的心跳聲和呼吸聲。

她曾參加無數的重要聯展，例如1995年第四十五屆威尼斯雙年展；1995年倫敦泰德美術館的「遷徙儀式：世紀末藝術」展；1998-99年的「真/生命：新英國藝術」在日本的五個美術館巡迴展出。她曾舉辦過幾個重要的個展，例如1997年在紐約現代藝術新美術館及芝加哥現代美術館；1998在牛津現代藝術美術館及愛丁堡的蘇格蘭國家現代藝術畫廊；2000年在大不列顛泰德美術館。她的作品可見於主要的公立典藏品中。她居住、工作於倫敦。

Hatoum was born in Beirut, Lebanon and studied at Beirut University College from 1970-72. She came to London in 1975 and became exiled when war broke out in the Lebanon shortly after her arrival. She studied at the Byam Shaw School of Art, London, 1975-79 and the Slade School of Art, London, 1979-81.

Known initially for her performance work, since the late 1980s she has made sculptures and environmental installations with video and sound which are rigorously pared down. Themes of surveillance and questions of identity are recurrent themes in her work. Her installation *Light at the End* was shown at the Showroom gallery, London in 1989. Using the simple means of six electric heating elements suspended vertically on a metal frame in a darkened corridor-like space, the work set up conflicting emotions of attraction and repulsion as the viewer was first drawn to the light only to be repelled by the heat. The work was later included in the touring exhibition *The British Art Show 1990*. She conceived the idea for *Corps étranger* as early as 1980 but the work was not realised until it was made for her solo exhibition at the Centre Georges Pompidou, Paris in 1994. It consists of a cylindrical structure with a film projected onto the floor featuring the journey of a camera through the insides of the artist's own body, accompanied by the amplified sound of her heart beat and breathing.

She has been included in numerous important group exhibitions including *Identita e Alterita: figure del corpo 1895-1995*, at the XLVI Venice Biennale, 1995; *Rites of Passage: Art for the End of the Century*, at the Tate Gallery, London, 1995, and *Real/Life: New British Art* which toured to five museums in Japan in 1998-99. She has had important solo exhibitions at the Chicago Museum of Contemporary Art and the New Museum of Contemporary Art, New York in 1997, the Museum of Modern Art, Oxford and the Scottish National Gallery of Modern Art, Edinburgh in 1998, and Tate Britain, London in 2000. Her work is included in major public collections. She lives and works in London.

Further reading

Guy Brett, Catherine de Zegher, Edward Said, an interview with Michael Archer, and writings by Piero Manzoni and Mona Hatoum: *Mona Hatoum*, Phaidon Press Limited, London, 1997

Edward W. Said, Sheena Wagstaff: *Mona Hatoum: The Entire World as a Foreign Land*, Tate Gallery Publishing, 2000

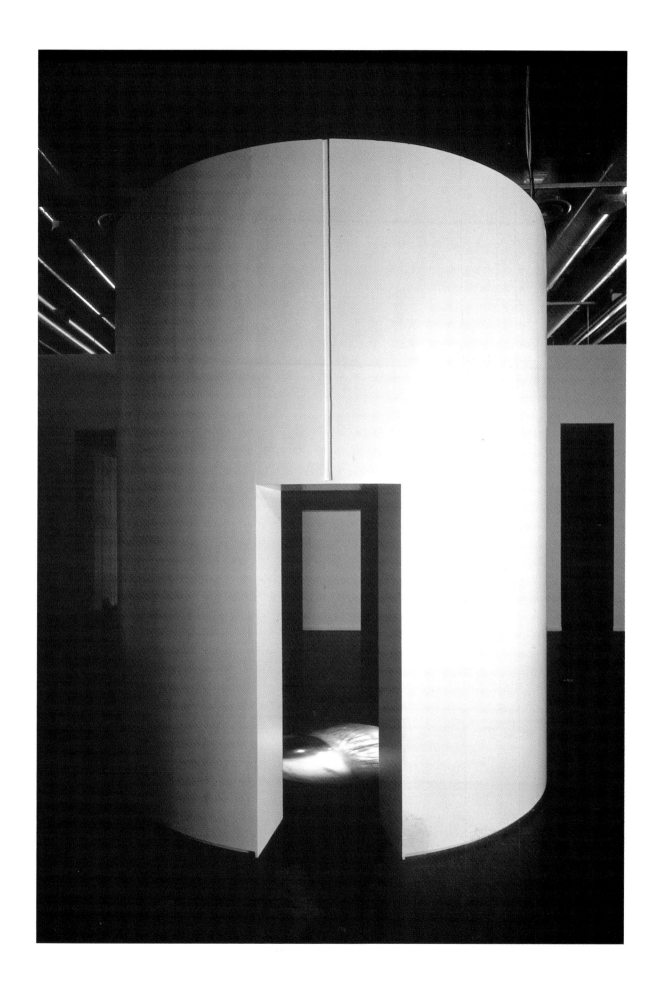

陌生的軀體，1994
Corps étranger
350 x 300 x 300

陌生的軀體（局部）1994
Corps étranger (detail)
350 x 300 x 300

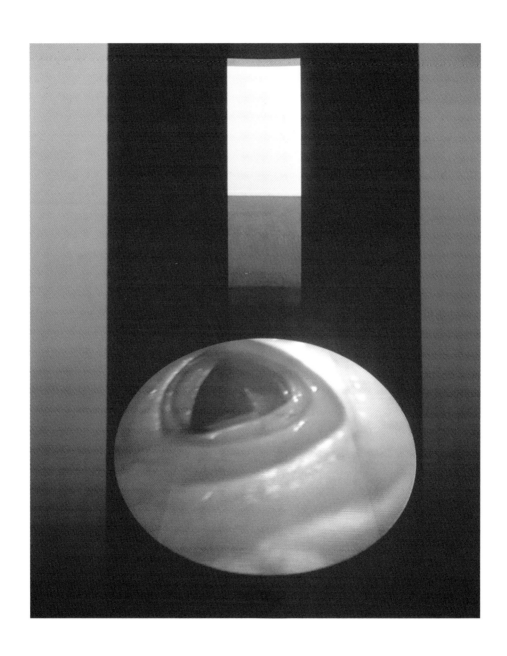

瑞秋・懷特雷
RACHEL WHITEREAD b. 1963

懷特雷生於倫敦。1982-85年她於布萊頓綜合藝術學院學習繪畫，1985-87在倫敦史萊德美術學院學習雕塑。1992年參加柏林DAAD藝術家計畫案。1993倫敦泰德美術館頒與泰納獎。同一年，被列於同輩重要藝術家之林，並翻鑄倫敦東區一棟廢棄的梯型房子內部作品「房子」，而享譽國際聲名大噪。

懷特雷直接以石膏、樹脂、橡膠等翻鑄日敘生活所熟悉的物品；留下來的的痕跡便是我們對此物體的回憶，一個提醒，也是一個負的印記。她的作品探討記憶與恍惚，翻鑄的雕塑是原始物體的證據。除了雕塑之外，她也使用攝影做為創作的一部份：建築物的結構，施工中或毀滅削除中的建築，街上的傢俱以及空屋等都被她拍攝影記錄。

1988年，第一次個展於倫敦加利利畫廊(Carlile Gallery)舉行。兩年後，在倫敦奇森海爾畫廊(Chisenhale Gallery)展出作品「鬼魅」，是翻鑄一棟維多利亞式房子中一間房間的石膏模型。1996年泰德美術館駐利物浦分館舉辦了一次大型個展，隨後次年便在馬德里蘇菲亞當代藝術中心舉辦另一次展覽。她也被推選代表英國參加第四十七屆威尼斯雙年展，在此展贏得一個獎項。2000年她承接在維也納開幕的大屠殺紀念館的計畫案。懷特雷的作品散見於許多國際主要收藏。目前居住、工作於倫敦。

Whiteread was born in London and studied painting at Brighton Polytechnic 1982-85, and later sculpture at the Slade School of Fine Art, London from 1985-87. In 1992 she participated in the DAAD Artists' Programme, Berlin and she was awarded the Turner Prize at the Tate Gallery, London in 1993. That same year she confirmed her position as one of the most important artists of her generation and gained international fame with *House*, a sculpture cast from the interior of a condemned terraced house in the East End of London.

Whiteread casts directly from familiar objects in plaster, resin and rubber, what remains is a reminder, a negative imprint. Her work traces memory and absence, the cast sculptures bearing evidence of the original object. In addition to her sculpture, she uses photography as part of her practice: photographs of structures, buildings under construction and demolition, furniture in the street, empty rooms.

Whiteread had her first solo exhibition in 1988 at the Carlile Gallery in London and two years later showed *Ghost* a plaster cast of a room in a Victorian house at the Chisenhale Gallery, London. In 1996 the Tate Gallery Liverpool mounted a major solo exhibition, and an exhibition quickly followed at the Palacio de Velazquez, Museo Nacional Centro de Arte Reina Sofia, Madrid the following year. She was selected to represent Britain for the XLVII Venice Biennale, for which she won a prize. Her major commission for the Holocaust Memorial in Vienna was inaugurated in 2000. Her work is represented in major international collections. Whiteread lives and works in London.

Further reading

James Lingwood, Iain Sinclair, Doreen Massey, Richard Shone, Anthony Vidler, Simon Watney, Jon Bird, Neil Thomas: *Rachel Whiteread: House*, Phaidon Press Limited, London, 1995

Fiona Bradley, Stuart Morgan, Bartomeu Mari, Rosalind Krauss, Michael Tarantino: *Rachel Whiteread: Shedding Life*, Tate Gallery Publishing, London, 1996

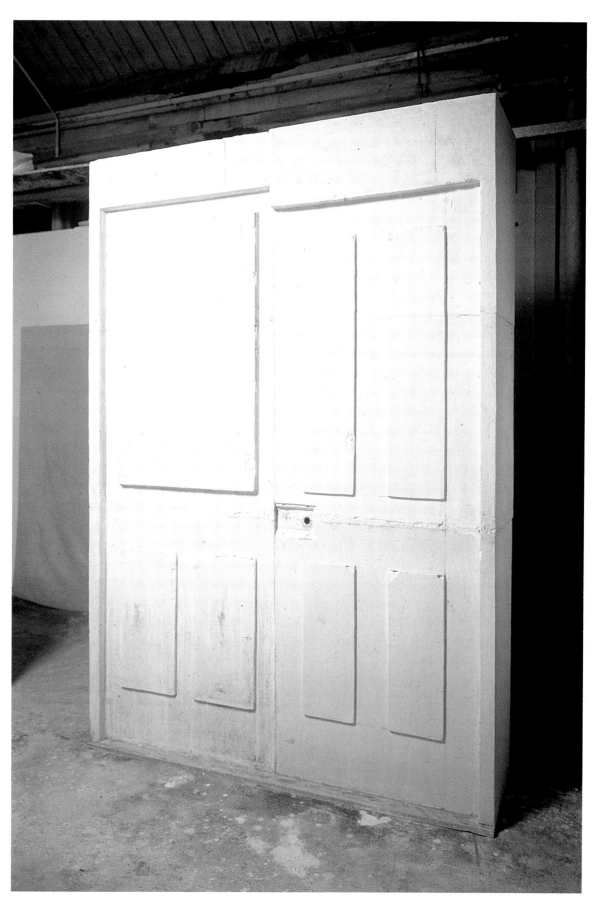

假門，1990
False Door
214.6 x 152.4 x 40.6

傢俱系列 · 1992-98
Furniture
20.3 x 25.4

房間系列，1996-98
Rooms
20.3 x 25.4

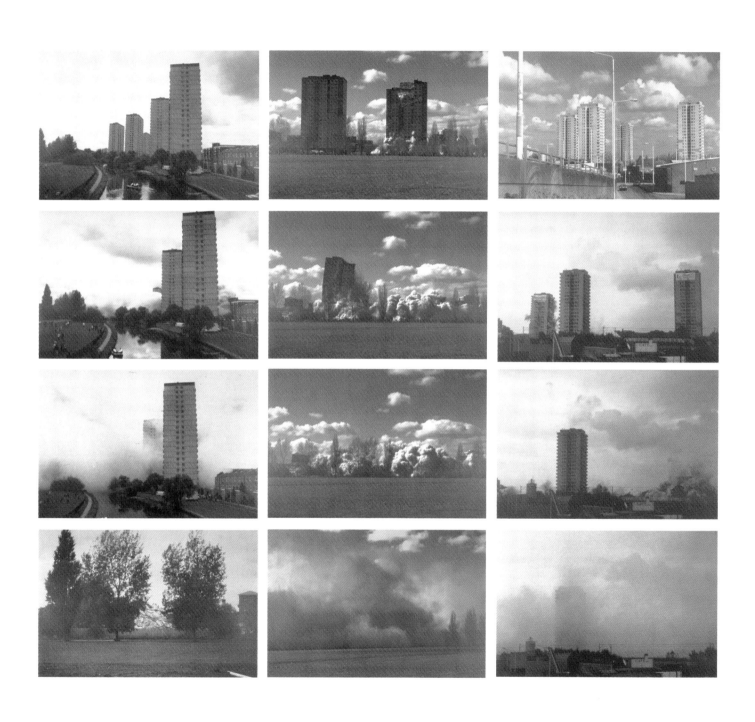

毀，1996
Demolished
49 x 74.5

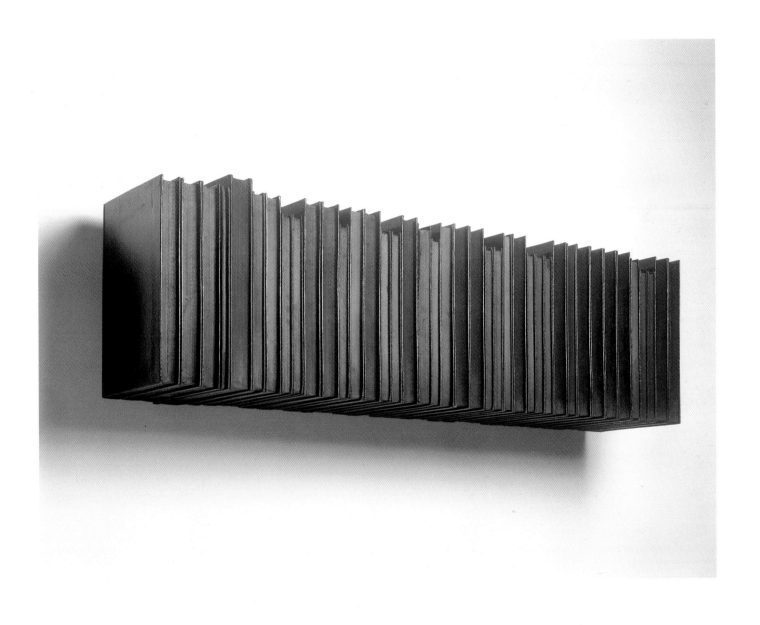

無題（黑色的書）， 1996-97
Untitled (Black Books)
29 x 101 x 23

戴彌恩・赫斯特
DAMIEN HIRST b. 1965

赫斯特生於英國西部港埠布里斯托市(Bristol)，1983-85年間就讀於里茲市(Leeds)的雅各・克萊姆藝術學院(Jacob Kramer College of Art)。1986-89年間，就讀於倫敦大學的哥德史密斯學院，1988年策劃了「凍凝」(Freeze)聯展，當時他還是一位學生，這是八〇年代末九〇年代初第一個由年輕藝術家策劃的聯展，在舊英國港都的一處廢棄的工業建築物內，如美術館般大小的空間內呈現了新一代藝術家的風貌。他所策劃的「凍凝」是此類型聯展的先鋒，這類聯展預示了英國藝術界的變化，許多展出的藝術家，都在後來十年中建立了國際聲望。赫斯特本人更是成為他同輩英國藝術家的個中翹楚。1995年獲英國泰德美術館頒「泰納獎」。

赫斯特認真地處理大主題如生命、愛情、慾望與死亡等，他最著名的作品之一，是1991年題為「某人心想肉體不可能死亡」，展出十二呎大虎鯊漂浮在甲醛溶劑的玻璃槽中，同一時期的其他裝置作品，包括動物屍體及蒼蠅、蝴蝶的生命週期。他不只製作雕塑類作品，自1988年起從事一項無止境的點畫系列，統稱為「藥學繪畫」(The Pharmaceutical Paintings)。他曾提及這些畫：「我開始創造這一系列無止境的繪畫，就像我腦海中的雕塑想法。一種科學方法之於繪畫，類似於藥物科學方法之於生命一般。」

赫斯特的第一次個展是在倫敦西區(West End)的一間空店中，名為「進出愛情」(In and Out of Love)。同年稍後，他在倫敦現代藝術機構有個主要個展。1992年獲邀第三屆國際伊斯坦堡雙年展；也受邀參展1993年第四十五屆威尼斯雙年展，在此項展覽他展出「分離的母子」，這件作品是一隻母牛與雛牛分裝於甲醛防腐劑中。1994年他為瑟本泰畫廊策展「有人瘋了，有人跑了」。1996年春天，他為海伍德畫廊的「神入：藝術與電影」導了一部片子「遊走」(Hanging Around)。

赫斯特的作品在許多重要聯展中均有展出，例如：1996年巴黎網球場美術館的「英國雕塑新世紀」；1997年在倫敦皇家藝術學院展出的「色煽腥：年輕英國藝術家—沙奇收藏展」。近十年他有許多個展，最近的是千禧年底在紐約嘉構思恩藝廊(Gagosian Gallery)。他的作品呈現在歐美重大典藏品中。他居住在迪文市(Devon)及倫敦。

Hirst was born in Bristol. He studied at Jacob Kramer College of Art, Leeds, 1983-85 and at Goldsmiths College, University of London, 1986-89. He curated the exhibition *Freeze* in 1988 whilst still a student. It was the first of the group of exhibitions organised and curated by young artists in the late 1980s and early 1990s which presented the work of a new generation of artists in museum sized spaces in disused industrial buildings in the old London docklands. These exhibitions signalled a change in the artistic landscape of Britain and many of the exhibited artists have established international reputations in the subsequent decade. Hirst has gone on to become the most famous British artist of his generation. He was awarded the Turner Prize at the Tate Gallery, London in 1995.

Hirst tackles the big subjects: life, love, desire and death, and his titles say as much, as in one of his most renowned works, *The Physical Impossibility of Death in the Mind of Someone Living* (1991) which featured a 12-foot tiger shark floating in a glass tank of formaldehyde. Other installation works from this time included animal corpses and the life cycles of flies and butterflies. In parallel to his sculptural works he has since 1988 worked on an unlimited series of dot paintings under the generic title *The Pharmaceutical Paintings*. He has said of these paintings: "I started them as an endless series like a sculptural idea of a painter (myself). A scientific approach to painting in a similar way to the drug companies scientific approach to life."

Hirst had his first solo exhibition *In and Out of Love* in an empty shop in the West End of London in 1991. Later that same year he had a major solo exhibition at the Institute of Contemporary Arts, London. A substantial showing of his work was included in the Third International Istanbul Biennial in 1992 and he was selected for the Aperto Section of the XLV Venice Biennale in 1993 where he showed *Mother and Child Divided*, a work consisting of a cow and calf split in two contained in two vitrines of formaldehyde. He curated the exhibition *Some Went Mad, Some Ran Away* for the Serpentine Gallery, London in 1994, and he directed a film, *Hanging Around* for the exhibition *Spellbound: Art and Film* at the Hayward Gallery, London in the spring of 1996. Hirst's work has been shown in many important group shows including *Un Siècle de Sculpture Anglaise* at the galerie nationale du Jeu de Paume, Paris 1996 and *Sensation: Young British Artists from the Saatchi Collection* at the Royal Academy of Arts, London in 1997. Throughout the last decade he has had many solo exhibitions, his most recent at the Gagosian Gallery, New York in late 2000. His work is represented in major collections in Europe and America. Hirst lives in Devon and London.

Further reading

Charles Hall, an interview with Sophie Calle: *Damien Hirst*, Jay Jopling and the Institute of Contemporary Arts, London, 1991

Gordon Burn, Stuart Morgan, and writings by the artist: *Damien Hirst: I want to spend the rest of my life everywhere, with everyone, to one, always, forever, now.* Booth-Clibborn Editions, London, 1997

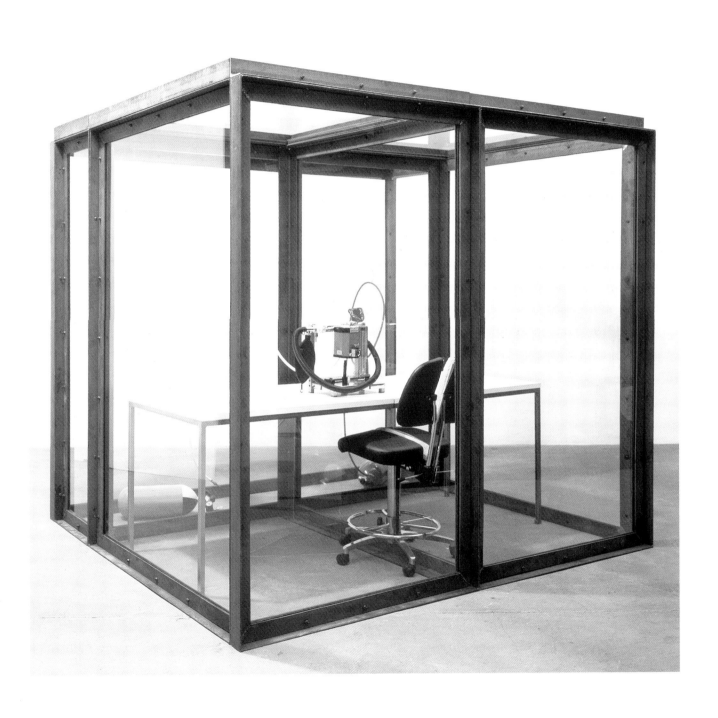

他試著內化所有事物， 1992-94
He tried to internalise everything
213 x 213 x 305

藥學丸子, 1994
Apotryptophanae
205.5 x 221

我會永遠愛你， 1994
I'll love you forever
121.9 x 121.9 x 76.2

麥可・蘭迪
MICHAEL LANDY　b. 1963

麥可・蘭迪出生於倫敦，於1981-1983年就讀於洛夫柏若
藝術學院（Loughborough），1985-88 年於倫敦大學哥
德史密斯學院學習。他參加過兩次聯展：一次是 1988 年
的「凍凝」(Freeze)聯展，由展出成員中哥德史密斯學院的
學生戴彌爾・赫斯特所策展；另一次是 1990 年的 「東鄉
園展」(East Country Yard Show) 由展出成員中哥德史密
斯學院的研究生莎拉・陸卡斯(Sara Lucas)所策展。1989
年一月，他的第一次個展於紐約的格瑞藝廊展出：同年的
九月，第一次倫敦個展於卡斯坦・書柏特(Karsten
Schubert Ltd.)公司登場。

蘭迪的作品專注於行銷學與消費主義的世界，批判近十五
年的英國政治經濟。1990 年，他改造一個廣大的工業空
間成為一想像的室內市場，標題便簡單地定為「市場」
(Market)；這件裝置作品省掉製造素材的麻煩，使用簡單
的器具展示，層層鋼鐵支架及假草裝飾的攤位，所用的便
是倫敦街頭攤販所使用的塑膠藍等物品，並且在現場播放
著小販每天使用同樣的物品搭建他們臨時攤位的流程錄影
帶。1992年的「結業大拍賣」(Closing Down Sale)，他將
卡斯坦・書柏特公司變成一個漫天叫價的商店，店中擺置
著放滿廉價消費品的市場手推車，上頭並顯目地標示著
「清倉大拍賣」，「結束營業」。1996 年，他的裝置作品
「廢物堆服務」(Scrapheap Services)，第一次在美國明尼
阿立司(Minneapolis)，渥克藝廊 (Walker Art Center)的
「出色！倫敦新藝術」 (Brilliant!New Art from London)展
中展出，他以老大哥的身份，嘲諷重複浪費與處置能力。
2001年二月在倫敦西區心臟地帶的一間廢棄的百貨公司展
出最近新作「折斷」(Breakdown) 約十四日之久，在那一刻
蘭迪有系統地破壞他畢生所擁有的七千件個人物品，是對
消費主義的最後聲明。

蘭迪的作品在許多重要聯展中均有展出，例如 1997 年在
倫敦皇家藝術學院展出的「色煽腥：年輕英國藝術家 - 沙
奇收藏展」；1997年於海伍德畫廊參展「物質文化：八〇
與九〇年代英國藝術」 (Material Culture:The Object in
British Art of the 1980s and '90s) 也受邀於2000年海伍
德畫廊策劃的國家巡迴展覽「英國藝術展(五)」(The British
Art Show 5)中。他的作品散見於重要的收藏品。

Landy was born in London. He studied at Loughborough
College of Art, 1981-83 and Goldsmiths College, University of
London, 1985-88. He participated in the group exhibition
Freeze, curated by fellow Goldsmiths' student Damien Hirst in
1988, and in the *East Country Yard Show* curated by fellow
Goldsmiths' graduate Sarah Lucas in 1990. His first solo
exhibition was in January 1989 at the Gray Art Gallery, New
York, and his first solo exhibition in London was in September
of that same year at Karsten Schubert Ltd.

Landy's work has focused on the world of marketing and
consumerism, commenting on the political and social climate
in Britain over the last decade and a half. In 1990 he
transformed a vast industrial space into an imaginary indoor
market for his installation work simply titled *Market*.
Completely devoid of produce, the installation used only the
basic apparatus of display: tiered steel framed stalls with a
fake grass covering, plastic crates and other items as used
by London street traders, with video monitors playing film
sequences of actual traders going about their daily business
of setting up their stalls using the same materials. For his
1992 *Closing Down Sale*, he turned the Karsten Schubert
gallery into a bargain shop with trolleys full of cheap
consumer items and day-glo signs exclaiming such slogans
as 'Recession Sale' and 'Out of Business'. His installation
Scrapheap Services, first shown in the exhibition *Brilliant!
New Art from London* at the Walker Art Center, Minneapolis in
1996, had more obviously sinister overtones of redundancy
and disposability in a 'big brother' state. For his most recent
work *Breakdown*, presented over 14 days in a disused
department store in the heart of the West End of London in
February 2001, Landy systematically broke down every
single thing he owned at that point in his life, over 7000
individual items, the ultimate statement on consumerism.

Landy work has been seen in many important group
exhibitions, including *Sensation: Young British Artists from
the Saatchi Collection* at the Royal Academy of Arts, London
in 1997, *Material Culture: The Object in British Art of the
1980s and '90s* at the Hayward Gallery, London also in 1997,
and *The British Art Show 5* , a National Touring Exhibition
organised by the Hayward Gallery, London in 2000. His work
is included in major collections. He lives and works in
London.

Further reading

Kate Bush: *Michael Landy: Market*, One-Off Press, London,
1990

Michael Landy/Breakdown, an interview with Julian
Stallabrass, Artangel, London, 2001

挪用一號， 1990
Appropriation 1

挪用二號， 1990
Appropriation 2

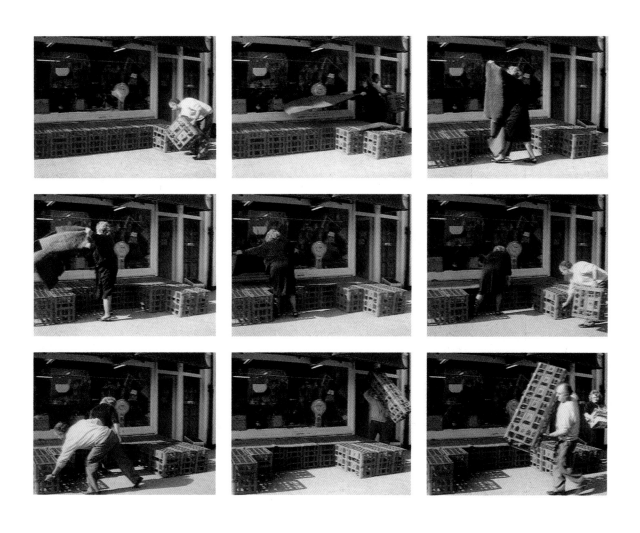

挪用三號，1990
Appropriation 3

花販攤第三號，1991
Costermonger's Stall nº 3
239 x 183 x 122

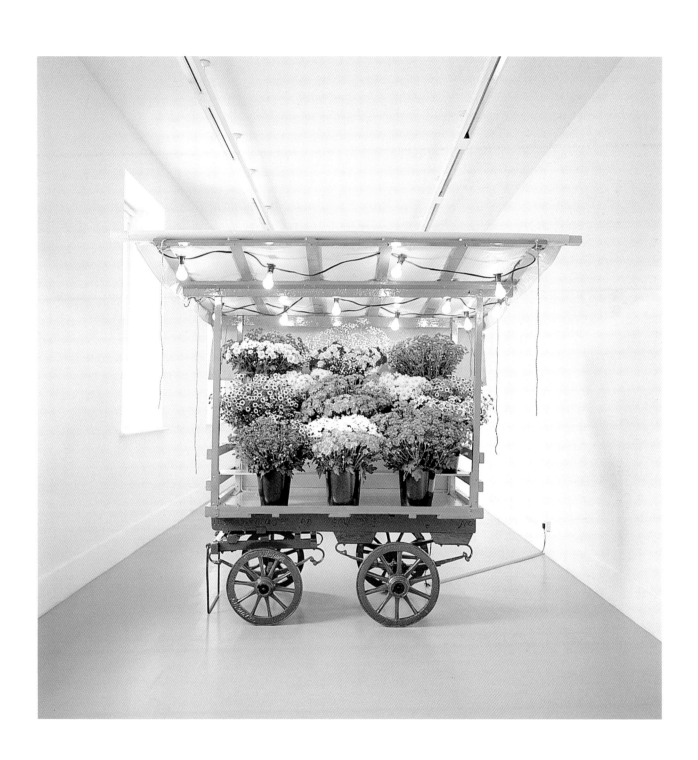

安雅・葛拉契歐
ANYA GALLACCIO b. 1963

葛拉契歐生於蘇格蘭的佩斯里(Paisley)。1984-85年她就讀於倫敦京斯頓綜合技術學院(Kingston Polytechnic)；1985-88年就讀於倫敦大學哥德史密斯學院。1997年承接德州聖安東尼奧市的「藝術步伐國際藝術家計畫案」的駐市藝術家工作。1998年她獲頒羅馬英國學校的Sargent獎。1999年她擔任日本神奈川(Kanazawa)的駐市藝術家。她也參加了1988年哥德史密斯學院學生戴彌恩・赫特斯策展的「凍凝」聯展，以及1990年哥德史密斯學院研究生莎拉・盧卡斯所舉辦的「東鄉園展」。

葛拉契歐的作品關注於時間的持續性變化與影響。使用的素材有切花、巧克力、冰、燃燒的蠟燭與鹽等，這些材料都是不能持久的，作品也不可避免地有「短暫」的特質，她的方法通常是裝置好作品，接著便有腐化或分裂等的過程。她最富戲劇性的裝置作品之一是「張力與表面」，於1996年於倫敦瓦平(Wapping)抽水站展出，她建構了一個三十二噸重的冰袋，經過三個月的時間冰才會全化為水，在其結構的中心埋了一塊鹽石。雖然作品的短暫意味著作品只能存在於記憶或攝影記錄之中，但這形成她作品中連實與重要的主體，而使她在英國藝術界佔有重要的一席。

1991年她第一次個展於卡斯登・舒伯特公司展出，自那時開始廣泛地在歐美、日本展出。她也參加過無數重要聯展，例如：1995年「出色：倫敦新藝術」聯展；1995-96年國家巡迴展「英國藝術展(四)」；1997年海伍德畫廊的「八〇與九〇年代英國藝術要件」及雪梨市現代美術館的「英國藝術展」；1998-99年巡迴日本五個美術館的「真實／生命：英國藝術」。葛拉契歐居住於倫敦，並在該地工作。

Gallaccio was born in Paisley, Scotland. She stutied at Kingston Polytechnic, London 1984-85 and Goldsmiths College, University of London 1985-88. She undertook a residency on the Art Pace International Artists' Programme, San Antonio, Texas in 1997, was awarded a Sargent Fellowship, British School at Rome in 1998, and was artist-in-residence at the Kanazawa Art Academy, Japan in 1999.

Gallaccio's work is concerned with constant change and the effects of time. Using materials such as cut flowers, chocolate, ice, burning candles and salt, there is an inevitable impermanence about her work and her approach often involves setting up an installation which then evolves through the process of decay and disintegration. For one of her most dramatic installations, *Intensities and Surfaces*, staged at Wapping Pump Station, London in 1996, she built a 32 ton stack of ice, which melted over a period of three months aided by a boulder of salt buried in the centre of the structure. Although the impermanence of her work has meant that her installations now live on in the memory and through photographic records, she has created a major body of work which has given her an important place in British art.

Her first solo exhibition was at Karsten Schubert Ltd, London in 1991, since when she has shown extensively in Europe, the USA and Japan. She has participated in numerous important group exhibitions, including *Brilliant ! New Art from London* at the Walker Arts Center, Minneapolis in 1995; *The British Art Show 4*, a national touring exhibition in 1995-96; *Material Culture: The Object in British Art of the 1980s and '90s*, the Hayward Gallery, London and *Pictura Britannica: Art from Britain*, the Museum of Contemporary Art, Sydney, both in 1997; and *Real/Life: New British Art*, which toured to five Japanese museums in 1998-99. Gallaccio lives and works in London.

Further reading

Michael Archer: *Anya Gallaccio*, Galerie Krinzinger, Vienna, 1993

Ralph Rugoff, an interview with Andrew Nairne: *Anya Gallaccio: Chasing Rainbows*, Tramway, Glasgow and Locus +, Newcastle-upon-Tyne, 1999

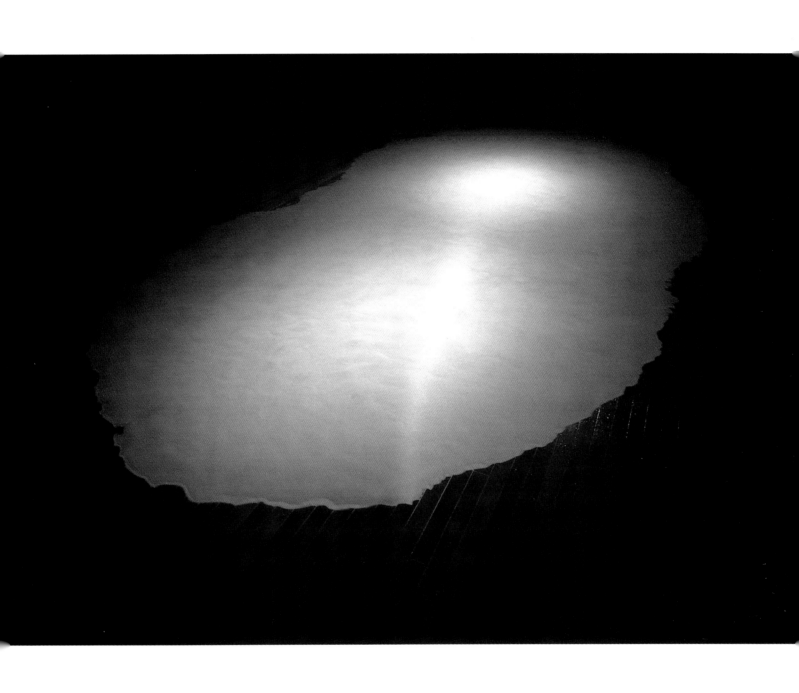

追尋彩虹，1998
Chasing Rainbows
dimensions variable
尺寸視場地而定

麥特・克里修
MAT COLLISHAW b. 1966

克里修出生於諾丁罕,並於1985-86年就讀於諾丁罕特蘭特綜合技術學院,於1986至89年就讀於倫敦大學哥德史密斯學院。他尚為學生時,便參加戴彌恩・赫斯特於1988年所策劃的「凍凝」聯展,稍後又參加1990年的「現代醫學」聯展,此展是大倉庫展覽之一,這類大倉庫展覽在九○年代末十分盛行,對倫敦藝術景觀的改造大有幫助。

克里修作品的重心是攝影的力量。他利用數位的方式來處理的自然意象創造出另一個的奇幻世界。1996年在「傳染花朵」燈箱作品裡,包含了豔麗異國風情的花朵攝影,進一步仔細觀察卻發現花朵部分已被疾病蹂躪。有一些作品是關於侷限的特定空間或以請君入甕的觀念,這些觀念均來自攝影工作的啟示,在攝影室捕捉生活中點滴,使其再現於一頁相紙上。1995-96年國家巡迴展「英國藝術展(四)」中,他展出一件題為「歌的循環」的作品,先將八隻鸚哥鳥放在一個籠中,再將錄好的鳥聲再播放給鸚哥鳥們聽,接著沈寂一會兒,然後鸚哥鳥便啾啾回應,如此便有了永無止境的循環鳥聲。這種操作形式使觀眾無法察覺何者是真聲,何者是錄製的或何者為真,何者是假。不管作品是大是小,克里修的作品帶著少見的催眠般的美感,但強制與焦躁感也在其間交替出現。

1990年他有兩次個展,分別在河濱畫室(Riverside Studios)及卡斯坦・舒伯特公司。1992年第一次於紐約科漢畫廊(Cohen Gallery)展出。1993年他被選為第四十五屆威尼斯雙年展及第四屆伊斯坦堡雙年展中「開放展」(Aperto)部分的藝術家。他參加過無數的聯展,包括:1995年「出色:倫敦新藝術」聯展;1996年渥夫斯堡(Wofsburg)世界美術館的「客滿」聯展;1996年巴黎村的現代藝術美術館的「生命/活著」聯展;1998-99年巡迴日本五個美術館的「真實/生活」展。他的作品見於主要公立機構典藏品中。克里修居住、工作於倫敦。

Collishaw was born in Nottingham and studied at Trent Polytechnic, Nottingham, 1985-86. He then moved to Goldsmiths College, University of London where he studied 1986-89. Whilst still a student, he participated in the group exhibition *Freeze*, curated by fellow Goldsmiths' student Damien Hirst in 1988, and later in *Modern Medicine*, 1990, another of the warehouse exhibitions which helped change the artistic landscape of London at the turn of the decade.

Collishaw's work has centred on the power of the photograph. He has been associated with images of nature which have been digitally manipulated to create alternative fantasy worlds. The *Infectious Flowers* lightbox works of 1996 contain photographs of seemingly exotic flowers which on closer inspection are found to have parts ravaged by disease. A number of works deal with the notion of limited space or entrapment which he has said comes from working with photography - a way of trapping something from life on a piece of paper. For the national touring exhibition *The British Art Show 4* in 1995-96, he exhibited a work *Song Cycle* which comprised eight budgerigars in a cage. The noise of the birds was recorded and played back to them after a short delay to which they then responded, creating an endless cycle of bird song. Again, a form of manipulation which leaves the viewer unable to detect what is real or recorded, true or false. Whether small scale or large, Collishaw's work has a rare hypnotic beauty which is by turns compelling and disturbing.

He had two solo exhibitions in London in 1990, at Riverside Studios and Karsten Schubert Limited, and his first solo exhibition in New York at the Cohen Gallery in 1992. He was selected for the Aperto Section of the XLV Venice Biennale in 1993 and the 4th Istanbul Biennial in 1995. He has been in numerous important group exhibitions including *Brilliant! New Art from London* at the Walker Art Center, Minneapolis in 1995, *Full House* at the Kunstmuseum Wolfsburg in 1996, *life/live* at the Musée d'Art Moderne de la Ville de Paris in 1996, and *Real/Life: New British Art* which toured to five museums in Japan in 1998-99. His work is represented in major public collections. Collishaw lives and works in London.

Further reading

Stuart Morgan, Francoise Jaunin, an interview with Alison Sarah Jacques and text by Mat Collishaw: *Mat Collishaw*, Galerie Analix - B & L Polla, Geneva, 1993

Jon Thompson: *Mat Collishaw*, Artimo Foundation, Breda, Netherlands, 1997

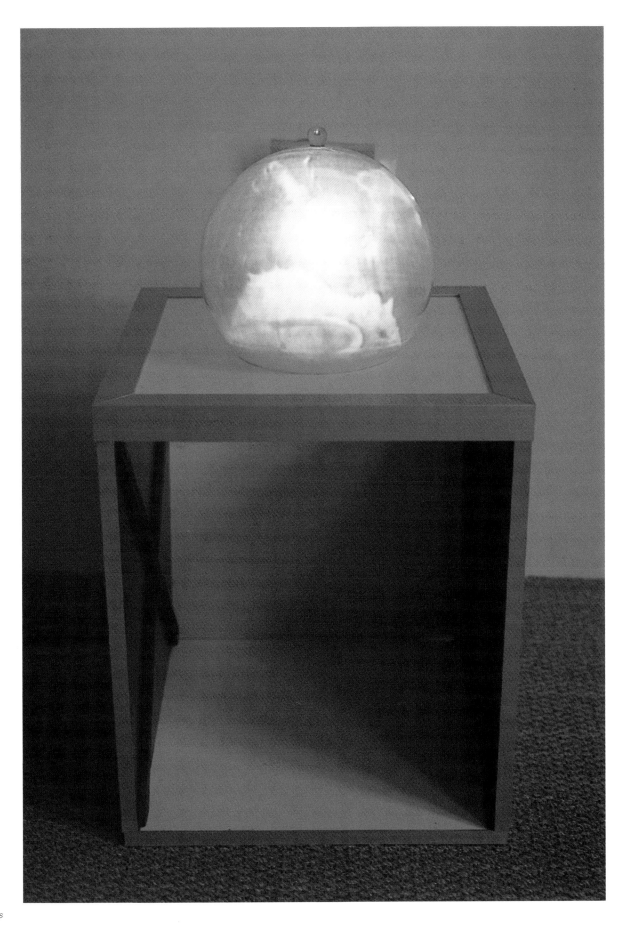

煙與鏡子，1996
Smoke'n Mirrors
80 x 44 x 48

無題（冷凍鳥）, 1994
Untitled (Frozen Birds)
28 X 20.4 each

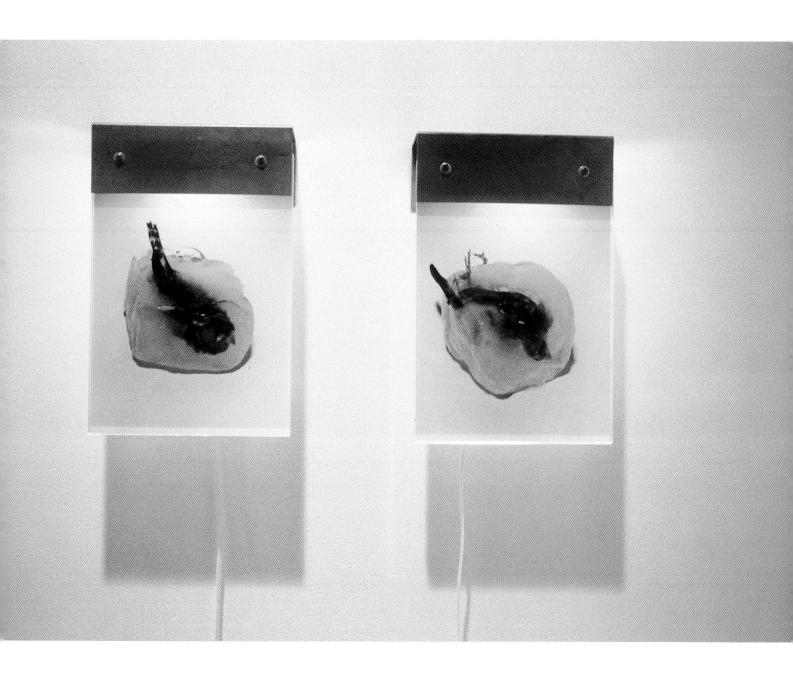

道格拉斯·葛登
DOUGLAS GORDON b.1966

葛登出生在蘇格蘭西南部的格拉斯哥市。1984-88年就讀格拉斯哥(Glasgow)藝術學校；1988-90年就讀於倫敦大學史萊德藝術學院。他多次獲得獎項：1996年泰德美術館的泰納獎；1997年的科隆藝術聯盟首獎；1997年第四十七屆威尼斯雙年展2000首獎；1998年紐約古金漢美術館的雨果獎。他參與了1997-98年柏林及漢諾瓦的DAAD藝術家計畫案。

葛登的創作媒材多樣化。他曾從事表演藝術、繪畫、裝置藝術，特別是利用錄影來探討人的感知、記憶及健忘症等。1993年他第一次個展在格拉斯哥市的特姆威畫廊(Tramway Gallery)展出，作品名為「二十四小時心理分析」，這個作品現被視為持續發展性的作品。他在此展中，第一次使用播放影片，他放慢希區考克(Alfred Hitchcock)影片的速度，使得影片長度持續一整天。葛登說他自己的作品：「觀眾被拉回過去，回憶原始的情節，然後又被推回未來，期待看到自己熟悉的過程，但過程永遠不夠快。」1994年的「1秒10尺」(10ms-1)是一部酒精治療短片，鏡頭轉接於錄影機上，然後投射到展覽空間中的一個大型懸空銀幕上，影片敘述一個男人受了創傷無法保持自身的平衡。避開影片的原始治療不談，觀眾不知如何回應面前播放的情景，到底是繼續看受難者忍受痛楚呢？還是撇頭離去？葛登承認：「害怕、排斥與迷惑等都是精神心理科學與電影世界中的關鍵情緒反應。」

葛登參加多次英國及國際的展覽，他在下列各地展出主要個展：1993年及2000年，巴黎現代美術館；1995年，巴黎龐畢度中心；1998年，漢諾瓦藝術聯盟；1999年，里斯本(Lisbon)貝蘭文化中心。他也參加過多次聯展：1995年第四十六屆威尼斯雙年展中「總解放：年輕英國藝術家」聯展；1996年倫敦海伍德畫廊展出的「神入：藝術與影片」；1998年斯德哥爾摩現代美術館「傷口：現代藝術的民主與救贖」；2000年倫敦大不列顛泰德美術館「才智：新英國藝術2000」。1999年，他有兩次新作發表，一次在紐約迪亞(Dia)藝術中心展出「雙重印象：史坦•道格拉斯與道格拉斯•葛登」，另一次在倫敦阿坦格爾藝廊(Artangel Projects)展「影片特徵」。他的作品廣見於世界各重要典藏。葛登居住於英國格拉斯哥市及紐約市，並在兩地工作。

Gordon was born in Glasgow. He studied at Glasgow School of Art, 1984-88 and the Slade School of Art, University of London, 1988-90. He has won numerous awards including the Turner Prize at the Tate Gallery, London, 1996, the Central Kunstpreis, Kunstverein Cologne, 1997, the Premio 2000 at the XLVII Venice Biennale 1997, and the Hugo Boss Prize at the Solomon R. Guggenheim Museum, New York, 1998. He participated in the DAAD Artists' Programme, Hannover and Berlin, 1997-98.

Gordon has worked in various media. He has used performance, painting, installation, text and in particular film for his investigations into perception, memory and amnesia. For his first solo exhibition, at Tramway, Glasgow in 1993, he made what is now regarded as a seminal work, *24 Hour Psycho*. The first time in which he used existing film footage, he slowed down the famous Alfred Hitchcock film so that it lasted an entire day. Gordon has said of this work: "the viewer is pulled back into the past in remembering the original, then pushed into the future in anticipation of a preconceived narrative that will never appear fast enough." For *10ms-1*, 1994, a short piece of vintage medical film footage transferred to video is projected on to a large freestanding screen which occupies the centre of the exhibition space. The film depicts a man suffering from some sort of traumatic injury and he is unable to keep his balance. With the original purpose of the medical film removed, the audience is uncertain how to respond to the compelling scenario being played out before them, whether to watch or turn away from the pain of the victim. Gordon has acknowledged: "fear and repulsion and fascination are critical in both the world of this science (neuropychology) and the world of cinema."

Gordon has exhibited extensively in Britain and internationally. He has had major solo exhibitions at the Musée d'Art Moderne de la Ville de Paris, 1993 and 2000, Centre Georges Pompidou, Paris, 1995, Kunstverein Hannover, 1998, and Centro Cultural de Belem, Lisbon, 1999. He has participated in numerous group shows including *General Release: Young British Artists at Scuola di San Pasquale*, XLVI Venice Biennale, 1995, *Spellbound: Art and Film*, Hayward Gallery, London, 1996, *Wounds: Between Democracy and Redemption in Contemporary Art*, Moderna Museet, Stockholm, 1998 and *Intelligence: New British Art 2000*, Tate Britain, London. He had major presentations of new work in *Double Vision: Stan Douglas and Douglas Gordon* at the Dia Center for the Arts, New York, and *Feature Film*, Artangel Projects, London, both in 1999. His work is represented in major international collections. Gordon lives and works in Glasgow and New York.

Further reading

Eckhard Schneider, Lynne Cooke, Friedrich Meschede, Charles Esche: *Douglas Gordon*, Kunstverein Hannover, 1998

Thomas Lawson, Russell Ferguson, David Gordon and Douglas Gordon, and a conversation with Jan Debbaut: *Douglas Gordon: Kidnapping, Stedelijk Van Abbemuseum*, Eindhoven, 1998

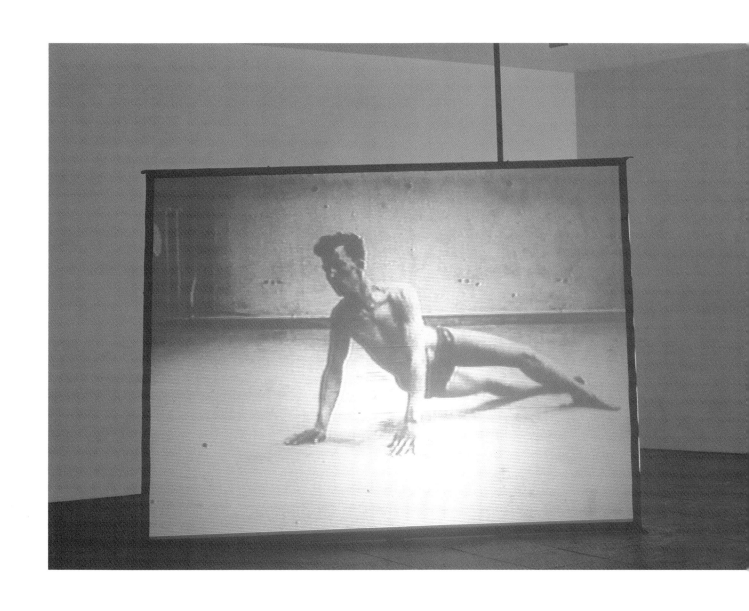

一秒十尺 1994
10 ms-1
螢幕 screen 228 × 305
竿子 pole 290 - 374

席奧蒡‧哈帕思卡
SIOBHÁN HAPASKA b.1963

哈帕思卡出生在北愛爾蘭首都貝爾費斯特(Belfast)。1985-88年就讀於倫敦市米德賽克斯綜合技術學院；1990-92年就讀於倫敦大學哥德史密斯學院。1998年她獲得都柏林市愛爾蘭現代藝術館的葛蘭‧丁不拉克斯(Glen Dimplex)獎項。她將代表愛爾蘭參加第四十九屆威尼斯雙年展。

哈帕思卡的雕塑在抽象與具象間不著痕跡地游移著。閃爍著蛋白石色的玻璃纖維作品懸置壁上，挑戰了一般的雕塑定義，讓人恍惚有在高速行駛中的記憶。裝置於地面上的作品，也有類似於懸掛玻璃纖維作品的高亮度塗料，但作品的形狀及題目顯示作品的有機性，她時常於作品中加入植物造型。超度寫實主義的雕塑時常與抽象作品並置，創造出不可預期的對峙。她說：「我想當有些人不能發現立即的、確實的解釋時，他們會變得非常不安。我喜歡漂浮的意念，當事情不是絕對時，會更加有趣，因為責任又丟回你的身上，你必須去瞭解你自己可能為何。」

她1995年於倫敦現代藝術機構展出「失腿的聖克里斯多夫」，1997年卡地夫市(Cardiff)威爾斯畫廊藝術協會的奧瑞爾策劃她的巡迴個展。同年她獲選參加卡薩爾市(Kassel)的「第十屆文件大展」；第一次紐約個展於湯雅‧本納可達爾畫廊(Tanya Bonakdar Gallery)展出。1999年東京塞森藝術計畫(Saison Art Program)為其舉辦個展。2000年她與恩內斯托‧納托(Ernesto Neto)，查爾斯‧龍(Charles Long)在斯德哥爾摩的空斯特館(Magasin 3 Stockholm Konsthall)展出。其作品廣為世界重要典藏機構收藏。哈帕思卡居住在倫敦，並在該地工作。

Hapaska was born in Belfast. She studied at Middlesex Polytechnic, London 1985-88 and Goldsmiths College, University of London 1990-92. She was awarded the IMMA (Irish Museum of Modern Art, Dublin) Glen Dimplex Award in 1998, and has been selected to represent Ireland at the XLVIV Venice Biennale in 2001.

Hapaska's sculpture moves effortlessly between abstraction and figuration. Her glossy opalescent wall-mounted works in fibreglass defy definition, but are reminiscent of parts of vehicles associated with high-speed travel. Floor based works have a similar finish but their shapes and titles suggest something more organic, emphasised by the fact she has on occasion incorporated plant forms into the works. The hyper-realist sculptures, frequently shown alongside the abstracted works, create an unexpected counterpart. She has said: " I think some people get very uneasy when they can't find immediate, concrete explanations. I like ideas that are adrift. When things are not absolutes they become more interesting, because it throws the responsibility back on you, to understand what you might be."

Hapaska had a solo exhibition, *St Christopher's Legless*, at the Institute of Contemporary Arts, London in 1995. A touring solo show organised by Oriel, the Arts Council of Wales' Gallery, Cardiff followed in 1997. That same year she was selected to show in *Documenta X*, Kassel and had her first solo show in New York at the Tanya Bonakdar Gallery. She had a solo show presented by the Saison Art Programme, Tokyo in 1999 and was shown with Ernesto Neto and Charles Long at Magasin 3 Stockholm Konsthall in 2000. Her work is included in major collections. Hapaska lives and works in London.

Further reading

Kate Bush: *Siobhán Hapaska*, Oriel, The Arts Council of Wales' Gallery, Cardiff, 1997

James Roberts, an interview with Suzanne Cotter: *Siobhán Hapaska*, Saison Art Programme, Sezon Museum of Modern Art, Tokyo, 1999

嚮往，1997
Hanker
145 x 220 x 50

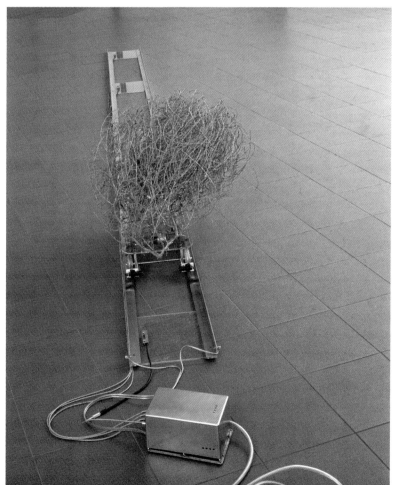

逸出，1997
Stray
67 x 500 x 70

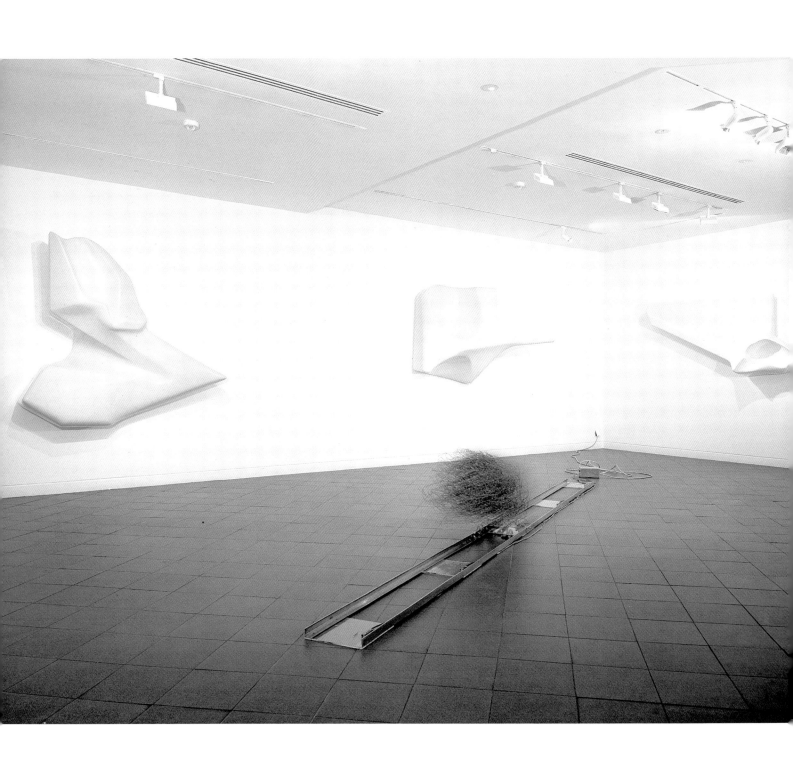

逸出，1997
Stray
67 x 500 x 70

審判者，1997
The Inquisitor
125 x 106 x 89

莎拉・盧卡斯
SARAH LUCAS b. 1962

盧卡斯生於倫敦。1987年,她由倫敦大學哥德史密斯學院畢業,並就讀於版畫學院。1988年參加由哥德史密斯學院學生戴彌恩・赫特斯策展的「凍凝」聯展以及1990年她自己擔任共同策展人的「東鄉園展」。

盧卡斯使用最簡單的素材,結合一種都會的感性,她的雕塑有一種粗獷的能量,以一種控苦式的幽默感面對自然,使觀眾驚奇和覺得興味。作品背後闡明嚴肅的主題,如性與死:1992年的「兩個煎蛋與土耳其餅(Kebab)」;1995年的「母豬」向傳統陳腔濫調的粗俗女人形象挑戰;1996年的「自殺是遺傳嗎?」死亡的主題顯而易見;1998年「生命是一種累贅器官」,作品特色在於一個燒焦的扶手椅子,一個用香菸做成的安全帽,兩輛燒焦的車子,車座與部分內部是以香菸裝飾。

1992年盧卡斯的第一次個展在瑞興市畫廊(City Racing Gallery)舉行,該畫廊位於倫敦南部,為藝術家們自辦的藝廊。1995年第一次紐約個展在芭芭拉・葛萊史東畫廊舉行。次年於陸特丹布門凡・布寧根美術館(Boymans-vanBeuningen)展出個展,英國BBC電視台「兩個瓜與一隻臭魚」節目曾報導此展,為該節目主題之一。她展出廣泛,作品可見於許多重要聯展,例如:1996年「出色:倫敦新藝術」聯展;1997年倫敦皇家藝術學院的「色爛腥:年輕英國藝術家一薩奇收藏展」;1998-99年在日本巡迴五個美術館的「新英國藝術家」展;2000年在倫敦大不列顛泰德美術館「才智:2000新英國藝術」展;2000年她在倫敦、東京及巴塞隆納均有個展,作品廣為國際重要機構典藏。她居住於倫敦,並於該地工作。

Lucas was born in London. She studied at the London College of Printing and graduated from Goldsmiths College, University of London in 1987. She participated in the group exhibition *Freeze*, curated by fellow Goldsmiths' student Damien Hirst in 1988, and the *East Country Yard Show*, which she co-curated in 1990.

Using the simplest of materials combined with an urban sensibility, Lucas's sculptures have a raw energy, the confrontational nature of which is undercut by a wry sense of humour leaving the viewer both provoked and amused. There are serious concerns which under-pin her work addressing such themes as sex and death. *Two Fried Eggs and a Kebab*, 1992 and *Bitch*, 1995, challenge accepted stereotypes with their crude portrayal of women; and death is very much in evidence in *Is Suicide Genetic*, 1996 and *Lifes a Drag Organs*, 1998, which feature respectively a burnt-out armchair with a crash helmet made of cigarettes, and two burnt-out cars with the seats and parts of the exteriors also decorated with cigarettes.

Lucas had her first solo exhibition in 1992 at City Racing, an artists' run gallery in south London, and her first solo show in New York at the Barbara Gladstone Gallery in 1995. The following year she had a solo exhibition at the Museum Boymans-van Beuningen, Rotterdam and was the subject of a BBC televison documentary, *Two Melons and a Stinking Fish*. She has exhibited widely and her work has been shown in many important group exhibitions including: *Brilliant! New Art from London* at the Walker Art Center, Minneapolis in 1996, *Sensation: Young British Artists from the Saatchi Collection* at the Royal Academy of Arts, London in 1997, *Real/Life: New British Art* which toured to five museums in Japan in 1998-99, and *Intelligence: New British Art 2000* at Tate Britain, London. In 2000 she had solo exhibitions in London, Tokyo and Barcelona. Her work is included in major international collections. Lucas lives and works in London.

Further reading

Jan van Adrichem, Angus Fairhurst: *Sarah Lucas*, Museum Boymans-van Beuningen, Rotterdam, 1996

Victoria Combalia, Angus Cook: *Sarah Lucas: Self-Portraits and More Sex*, Centre Cultural Tecla Sala, Barcelona, 2000

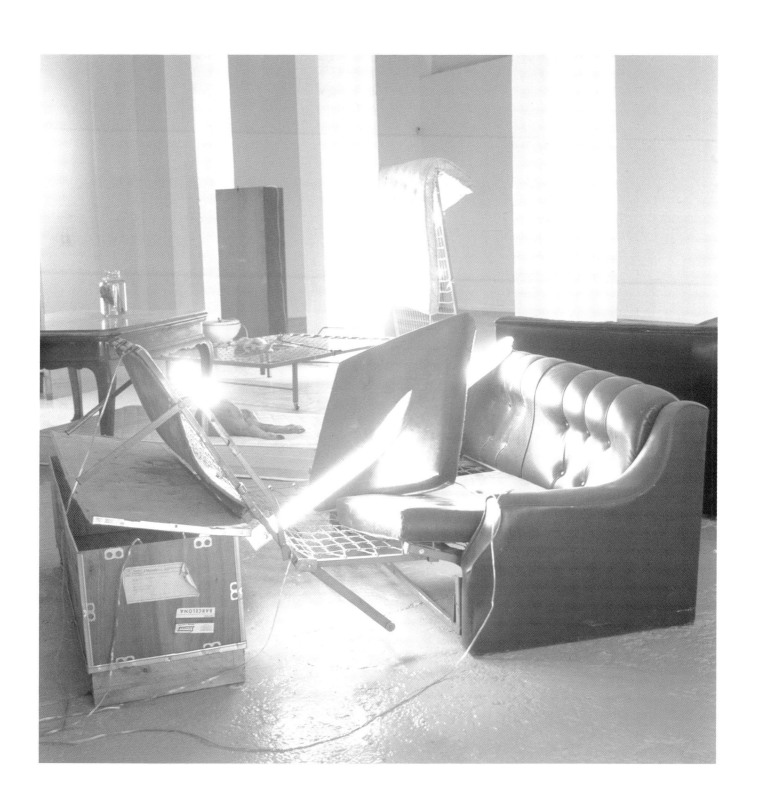

去他的命運, 2000
Fuck Destiny
95 x 165 x 197

自畫像，1990-1998，1999
Self-portraits 1990-1998

a.吃香蕉，1990
Eating a banana
60 x 80

b. 神聖的，1991
Divine
60 x 80

c. 自畫像與茶杯，1993
Self-portrait with mug of tea
80 x 60

d. 自畫像與燈籠褲，1994
Self-portrait with knickers
80 x 60

e. 自畫像與煎蛋，1996
Self-portrait with fried eggs
80 x 60

f. 人類馬桶(二)，1996
Human Toilet II
80 X 60

g. 以火攻火，1996
Fighting fire with fire
80 x 60

h. 自畫像與頭顱，1997
Self-portrait with skull
80 x 60

i. 得到一條鮭魚 第三號，1997
Got a Salmon on #3
80 x 60

j. 夏季，1998
Summer
80 x 60

k. 抽煙，1998
Smoking
80 x 60

l.再訪人類馬桶，1998
Human toilet revisited
80 x 60

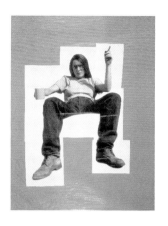

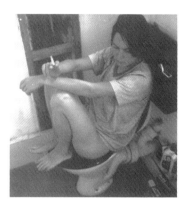

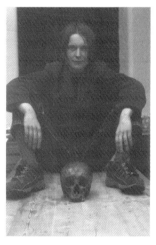
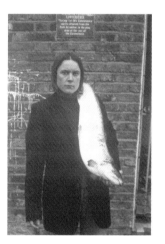
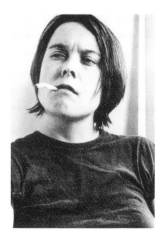
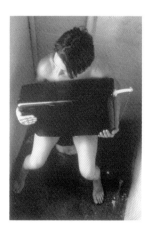

理查 · 威爾森
RICHARD WILSON b.1953

威爾森生於倫敦。1971-74年就讀於宏斯藝術學院；1992年他參與了柏林DAAD藝術計畫案。

威爾森利用既有的建築物創作，介入特定的空間中或實際的建築中進行創作。他已利用過如牆、窗戶、旅行車、溫室與游泳池等，來改造一個空間原本的環境及實質意義。他的最著名作品「晚上八點五十分」，完成於1987年，該作品的空間已成了一個機箱油的容器，他的作品可說是英國裝置作品的縮影。一件定點裝置作品實際遺留下來的只是相片、研究文字與模型。雖然威爾森的特定地點裝置作品的性質也是如此，但「晚上八點五十分」已在許多不同地點展出過，且能適應各個不同場所。這件作品是他1994年於美國洛杉磯現代美術館展出的兩件作品之一；另一件作品「深端」，是一件玻璃纖維做外殼的游泳池，加上六十英呎攀爬於美術館的屋頂的水管，這件作品是特別為了洛杉磯現代美術館及洛杉磯市而做。「太簡單了」則是位於英國東北名叫「弧」(Arc)的新藝術機構所委託製作的一件作品，該機構於1999年開幕使用。

其他永久陳列的特定地點裝置作品為：「一絲事實」，受倫敦千禧巨蛋新雕塑方案所委託製作，並於2000年完成，此作品在六百噸控沙機上做出一片垂直的區域。「朝北向日本74°33'2"」位於日本西部的新潟縣(Niigata Perfecture)，他用上色的鋼條搭製成他倫敦自宅的骨架，並且是位於同樣的高度，這件作品也於2000年完竣。

威爾森的第一次個展於倫敦船刊畫廊(Coracle Press Gallery)展出，他自八○年代中期至九○年代中期定期地在麥特畫廊(Matt's Gallery)展出，在該處時時可見到他的新作發表。1989年，他代表英國展出於第二十屆聖保羅雙年展中；1996年他在瑟本泰畫廊展出主要個展「阻塞的齒輪」(Jamming Gears)。他的作品廣為歐洲、美國、日本、澳洲等公私立機構典藏，居住於倫敦，並在該地工作。

Wilson was born in London. He studied at Hornsey College of Art, London, 1971-74, and Reading University, 1974-76. He participated in the DAAD Artists' Programme, Berlin in 1992.

Wilson works with existing architecture, creating interventions within a space or actual building. He has used walls, windows, caravans, greenhouses and swimming pools to transform the context and physical aspect of a space. His best known work, *20: 50*, 1987, where the space used becomes a container for a lake of sump oil, has come to epitomise installation art in Britain. Although the site specific nature of much of Wilson's work has often meant that all that is physically left of an installation are the photographs, studies and models, *20:50* has been shown in different venues and seemingly adapts itself to each space. It was one of two works shown in his major museum show in the United States at the Museum of Contemporary Art, Los Angeles in 1994. The other work, *Deep End*, consisting of a fibreglass hull of a swimming pool with a 60 foot pipe climbing up through the gallery roof, was created in response to the venue and the city of Los Angeles. A major sculptural intervention, *Over Easy*, commissioned for Arc, a new arts venue in the town of Stockton-on-Tees in the north-east of England was inaugurated in 1999. Other permanently sited works inlude: *Slice of Reality*, a vertical section taken from a 600 ton sand dredger commissioned for the Millenium Dome New Sculpture Project, London, completed in 2000, and *Set North for Japan 74° 33' 2"*, a skeletal representation of his own house in London made in painted steel and set at the same angle of elevation in Niigata Prefecture, western Japan, also completed in 2000.

Wilson had his first solo exhibition at Coracle Press Gallery, London. He exhibited regularly at Matt's Gallery in London from the mid 1980s to the mid 1990s, where some of his most memorable known installations were first seen. He represented Britain at the XX São Paulo Bienal in 1989 and he had a major solo exhibition, *Jamming Gears*, at the Serpentine Gallery in 1996. His work is included in public and private collections in Europe, the United States, Japan and Australia. Wilson lives and works in London.

Further reading

Richard Wilson: Deep End, an interview with Paul Schimmel, The British Council / The Museum of Contemporary Art, Los Angeles, 1995

Andrew Wilson: *Richard Wilson: Jamming Gears*, Serpentine Gallery, London, 1996

Michael Archer,Simon Morrisey, Harry Htocks: *Richard Wilson*, Merrell Publishing, London, 2001

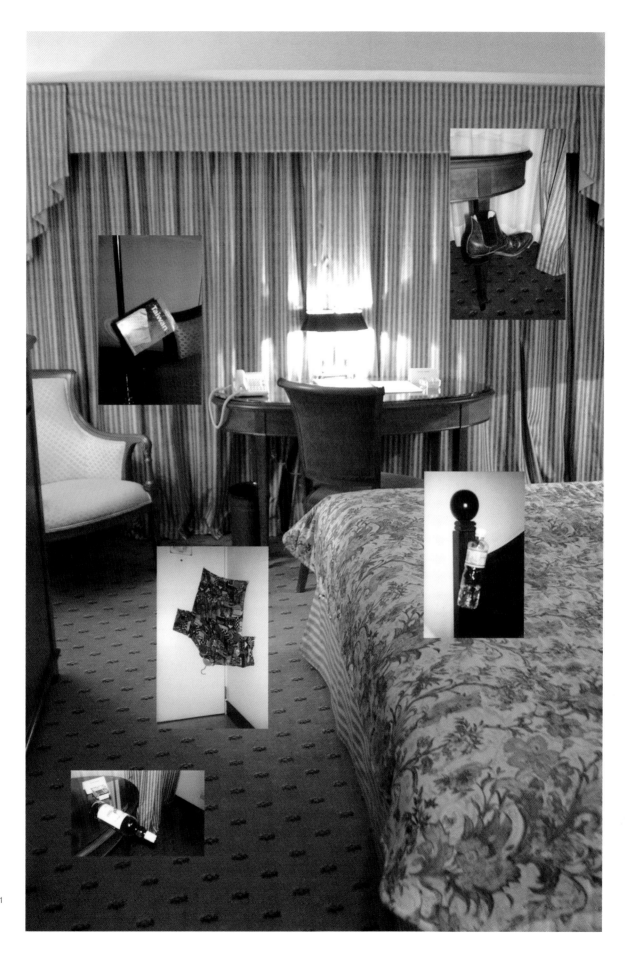

皇后飯店 **921** 房（局部）2001
921 Empress Hotel (detail)
305 x 550 x 366

皇后飯店 921 房草圖
Working drawing of *921 Empress Hotel*

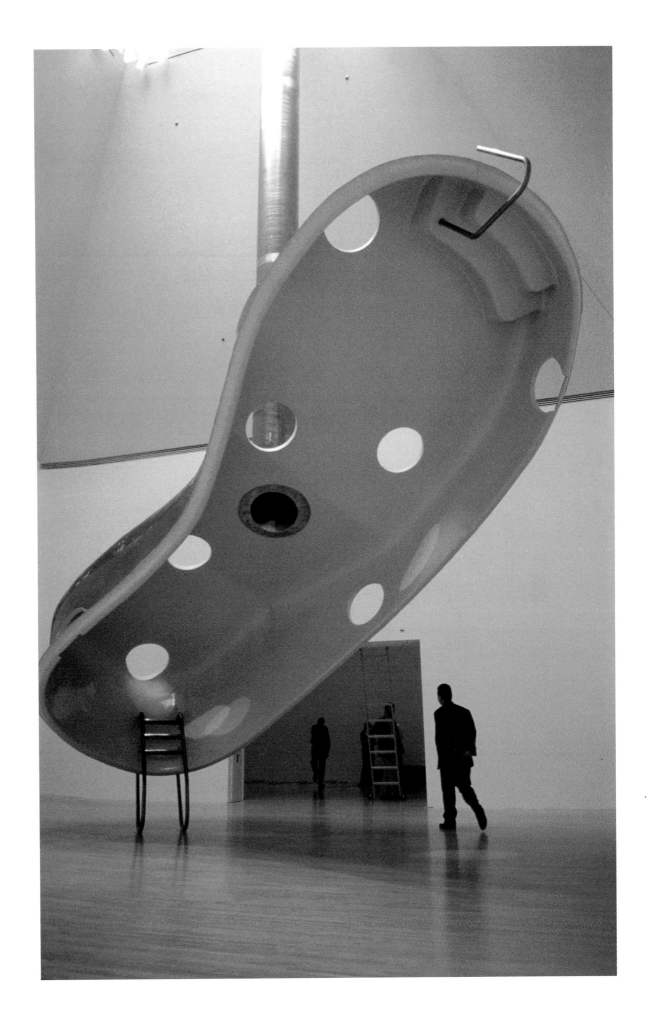

深端 1994
Deep End
660 X 366 X127

作品清單 List of works

（尺寸：長 x 寬 x 高 公分計, dimensions Height x Width x Depth in cms）

安東尼·卡羅 Anthony CARO

1
雕塑之七，1961
銅，漆綠、藍與棕色
178 x 537 x 105.5
倫敦私人收藏
安妮莉·朱達畫廊提供

Sculpture Seven, 1961
steel painted green, blue and brown
178 x 537 x 105.5
Private Collection, London
Courtesy of Annely Juda Fine Art

2
五月，1963
銅材與鋁，漆紫紅、橘與綠色
279 5 x 305 x 358.5
倫敦私人收藏
安妮莉·朱達畫廊提供

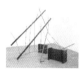

Month of May, 1963
steel and aluminium painted magenta,
orange and green
279 5 x 305 x 358.5
Private Collection, London
Courtesy of Annely Juda Fine Art

3
鼓翼，1976
銹鋼與亮光漆
63.5 x 75 x 198
倫敦私人收藏
安妮莉·朱達畫廊提供

Flap, 1976
steel rusted and varnished
63.5 x 75 x 198
Private Collection, London
Courtesy of Annely Juda Fine Art

菲利浦·金 Phillip KING

4
玫瑰花苞，1962
塑膠
60 x 72 x 72
藝術家自藏

Rosebud, 1962
plastic
153x 183 x183
Collection the Artist

5
漣漪，1963
塑膠
188 x 89 x 77
里斯本克洛斯特·臺本凱基金會收藏
里斯本

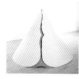

Ripple, 1963
plastic
188 x 89 x 77
Collection Fundacao Calouste
Gulbenkian
CAMJAP, Lisbon

愛德華·包羅契 Eduardo PAOLOZZI

6
四座塔，1963
鋁、琺瑯塗料
203.2 x 77.5 x 78.4
愛丁堡蘇格蘭國家美術館藏，1966 年藝
術家致贈

Four Towers, 1963
aluminium, enamel paint
203.2 x 77.5 x 78.4
Scottish National Gallery of Modern Art,
Edinburgh:
Presented by the artist 1966

7
杜勒斯之一，1967
鍍黃色鋼
131 x 79 x 16
英國文化協會收藏

Dollus I, 1967
chrome plated steel
131 x 79 x 16
The British Council

貝瑞·弗拉納格 Barry FLANAGAN

8
堆 第4號，1967
粗麻袋內裝填沙子
60 x 131 x 100
倫敦海伍德畫廊藝術協會收藏

Heap 4, 1967
hessian filled with sand
60 x 131 x 100
Arts Council Collection, Hayward
Gallery, London

9
草印之一，1967-68
黑白攝影
51 x78
英國文化協會收藏

Grass print1, 1967-68
B/W photograph
51 x 78
The British Council

10
草印之二，1967-68
黑白攝影
51 x 78
英國文化協會收藏

Grass print 2, 1967-68
B/W photograph
51 x 78
The British Council

11
草印之三，1967-68
黑白攝影
51 x 78
英國文化協會收藏

Grass print 3, 1967-68
B/W photograph
51 x 78
The British Council

12
69 年6月（二），1969
麻布、柳條
292.1 x 508 x 88.9
泰德美術館購於 1973 年

June (2) '69, 1969
flax sheet, willow wands
292.1 x 508 x 88.9
Tate : Purchased 1973

13
玩板球的人，1981
青銅
156.2 x 39.3 x 53.4
英國文化協會收藏

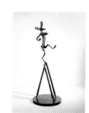

The Cricketer, 1981
bronze
156.2 x 39.3 x 53.4
The British Council

紀伯與喬治 GILBERT & GEORGE

14
如青年般的藝術家肖像，1972
錄影帶與裱框證書，25 之 7
倫敦海伍德畫廊藝術協會收藏

A Portrait of the Artists as Young Men,
1972
video and framed certificate, number 7
of 25
Arts Council Collection, Hayward
Gallery, London

15
戈登的店使我們喝醉，1972
錄影帶與裱框證書，25 之 6
倫敦海伍德畫廊藝術協會收藏

Gordon's Makes us Drunk, 1972
video and framed certificate, number 6
of 25
Arts Council Collection, Hayward
Gallery, London

16
在樹叢中，1972
錄影帶與裱框證書，25 之 9
倫敦海伍德畫廊藝術協會收藏

In the Bush, 1972
video and framed certificate, number 9
of 25
Arts Council Collection, Hayward
Gallery, London

17
粉碎，1977
照片（25 禎）
302.5 x 252.5
倫敦海伍德畫廊藝術協會收藏

Smash, 1977
photo piece (25 panels)
302.5 x 252.5
Arts Council Collection, Hayward
Gallery, London

理察・龍 Richard LONG

18
英格蘭，1968
黑白照片與本文
83.8 x114.3
英國文化協會收藏

England, 1968
B/W photograph with text
83.8 x 114.3
The British Council

19
非洲之圓，1978
黑白照片與本文
83.8 x 114.3
英國文化協會收藏

Circle in Africa, 1978
B/W photograph with text
83.8 x114.3
The British Council

20
三處荒野三個圓，1982
文本
106 x 164
英國文化協會收藏

Three Moors Three Circles, 1982
text
106 x 164
The British Council

21
春天之圓，1992
石板
直徑 300 cm
英國文化協會收藏

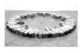

Spring Circle, 1992
Delabole slate
300 cm diameter
The British Council

麥可・克雷格・馬丁 Michael CRAIG -MARTIN

22
（與天體一起）閱讀，1980
尺寸視場地而定
牆面上貼膠帶
泰德美術館購於 1980

Reading (With Globe), 1980
tape on wall
Dimensions variable
Tate : Purchased 1980

湯尼・克雷格 Tony CRAGG

23
獨木舟，1982
塑膠、金屬、橡膠與木製品
長 800 cm
英國文化協會收藏

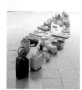

Canoe, 1982
found plastic, metal, rubber and wooden
objects
800 cm long
The British Council

24
喬治與龍，1984
塑膠、木頭與鋁
110 x 400 x 120
倫敦海伍德畫廊藝術協會收藏

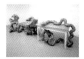

George and the Dragon, 1984
plastic, wood and aluminium
110 x 400 x 120
Arts Council Collection, Hayward
Gallery, London

理察・迪肯 Richard DEACON

25
男孩與女孩（出來玩），1982
油氈布與夾板
91.5 x 183 x 152.5
英國文化協會收藏

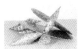

Boys and Girls (come out to play), 1982
linoleum and plywood
91.5 x 183 x 152.5
The British Council

26
為其他人而做的藝術 第6號，1983
鞣皮與黃銅
25 x 45 x 25
倫敦里森畫廊提供

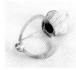

Art for Other people n° 6, 1983
suede and brass
25 x 45 x 25
Courtesy Lisson Gallery, London

27
為其他人而做的藝術 第12號，1984
大理石與皮革
42 x 35 x 20
倫敦里森畫廊提供

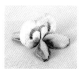

Art for Other People n° 12, 1984
marble and leather
42 x 35 x 20
Courtesy Lisson Gallery, London

28
眼睛的饗宴，1987
鋼鍍鋅與螺絲
170 x 245 x 280
藝術家自藏

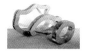

Feast for the Eye, 1987
galvanised steel with screws
170 x 245 x 280
Collection of The Artist

比爾・伍德卓 Bill WOODROW

29
烏鴉與腐肉，1981
傘
37 x 100 x 55
倫敦海伍德畫廊藝術協會收藏

Crow and Carrion, 1981
umbrellas
37 x 100 x 55
Arts Council Collection, Hayward
Gallery, London

30
車門、扶手椅與意外，1981
車門、扶手椅與琺瑯彩
120 x 300 x 300
倫敦私人收藏

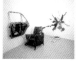

Car Door, Armchair and Incident, 1981
car door, armchair and enamel paint
120 x 300 x 300
Private Collection, London

31
豆子罐頭與管子，1981
錫罐與壓克力顏料
11 x 12 x 15
倫敦私人收藏

Bean Can with pipe, 1981
tin can and acrylic paint
11 x 12 x 15
Private Collection, London

32
照相機與蜥蜴，1981
照相機盒子
19 x 27 x 13
倫敦私人收藏

Camera and Lizard, 1981
box camera
19 x 27 x 13
Private Collection, London

33
電光火與黃色的魚，1981
電光器、琺瑯、壓克力顏料
27 x 37 x 19
倫敦私人藏品

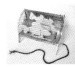

Electric Fire with Yellow Fish, 1981
electric fire, enamel and acrylic paint
27 x 37 x 19
Private Collection, London

34
玻璃罐，1983
茶壺、玻璃罐與壓克力顏料
28 x 31 x 20
倫敦私人收藏 ▌

The Glass Jar, 1983
tea pot, glass jar and acrylic paint .
28 x 31 x 20
Private Collection, London

理察・溫特渥斯 Richard WENTWORTH

35
玩具，1983
鍍錫鋼
31 x 41 x 62.5
倫敦海伍德畫廊藝術協會收藏

Toy, 1983
galvanised and tinned steel
31 x 41 x 62.5
Arts Council Collection, Hayward
Gallery, London

36
積雲，1991
木頭、玻璃、陶瓷
320 x 90 x 23
藝術家自藏，倫敦里森畫廊提供

Cumulus, 1991
wood, glass, ceramic
320 x 90 x 23
The Artist, Courtesy Lisson Gallery,
London

安東尼·貢利　Antony GORMLEY

37
在此世界之外，1983-84
鉛、玻璃纖維、黏土
130 x 120 x 90
英國文化協會收藏

Out of this World, 1983-84
lead, fibreglass, clay
130 x 120 x 90
The British Council

38
馬勒維奇的角落，1992
鉛、玻璃纖維、石膏與空氣
193 x 162 x 100
英國文化協會收藏

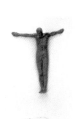

Corner for Kasimir, 1992
lead, fibreglass, plaster and air
193 x 162 x 100
The British Council

安尼許·克普爾　Anish KAPOOR

39
藍色的讚美詩，1983
聚苯乙烯、樹脂、石膏底與顏料
三件: 61 x 61 x 61
一件: 76 x 76 x 76
英國文化協會收藏

The Chant of Blue, 1983
polystyrene, resin, gesso and pigment
3 pieces: 61 x 61 x 61
1 piece: 76 x 76 x 76
The British Council

40
虛空，1994
玻璃纖維、聚苯乙烯與顏料
直徑 110 公分
英國文化協會收藏

Void, 1994
fibreglass, polystyrene & pigment
110 diameter
The British Council

蒙娜·哈同　Mona HATOUM

41
陌生的軀體，1994
錄影裝置與圓筒狀木製結構
350 x 300 x 300
巴黎龐必度中心收藏
國家現代美術館（藝術家複製品）

Corps etranger, 1994
video installation with cylindrical wooden
structure
350 x 300 x 300
Centre George Pompidou, Paris
Musee national d'art moderne (Artist's
copy)

瑞秋·懷特雷　Rachel WHITEREAD

42
假門，1990
石膏
214.6 x 152.4 x 40.6
英國文化協會收藏

False Door, 1990
plaster
214.6 x 152.4 x 40.6
The British Council

43
毀，1996
12 幅雙色絹印
49 x 74.5. 第 35 版
倫敦派洛根出版社收藏

Demolished, 1996
12 duotone screenprints
49 x 74.5. edition of 35
Paragon Press, London

44
無題（黑色的書），1996-97
黑色塑膠與鋼
29 x 101 x 23　第 10 / 10 版
英國文化協會收藏

Untitled (Black Books), 1996-97
black plastic and steel
29 x 101 x 23, edition of 10
The British Council

45
傢俱系列，1992-98
四幅彩色相紙沖洗
20.3 x 25.4
藝術家與倫敦安東尼·杜菲畫廊提供

Furniture series, 1992-98
4 R-type colour photographs
20.3 x 25.4 x 4 (pcs)
Courtesy of the Artist and Anthony
D'Offay Gallery, London

46
房間系列，1996-98
四幅彩色相紙沖洗
20.3 x 25.4
藝術家與倫敦安東尼·杜菲畫廊提供

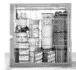

Rooms series, 1996-98
4 R-type colour photographs
20.3 x 25.4
Courtesy of the Artist and Anthony
D'Offay Gallery, London

戴彌恩·赫斯特　Damien HIRST

47
他試著內化所有事物，1992-94
玻璃、鋼、桌、椅、瓦斯桶
213 x 213 x 305
倫敦海伍德畫廊藝術協會收藏

He tried to internalise everything, 1992-
1994
glass, steel, table, chair, gas compres-
sor
213 x 213 x 305
Arts Council Collection, Hayward
Gallery, London

48
我會永遠愛你，1994
鋼質籠子、掛鎖與醫療廢棄物容器
121.9 x 121.9 x 76.2
英國文化協會收藏

I'll love you forever, 1994
steel cage, padlock and medical waste
containers
121.9 x 121.9 x 76.2
The British Council

49
藥學丸子，1994
家用亮光漆、乳化劑與畫布
205.5 x 221
英國文化協會收藏

Apotryptophanae, 1994
household gloss and emulsion paint on
canvas
205.5 x 221
The British Council

麥可·蘭迪　Michael LANDY

50
挪用一號、二號與三號，1990
三台電視機
賽門與賽門收藏

Appropriation 1, 2 and 3, 1990
3 monitor video work
Collection of Simmons & Simmons

51

花販攤第三號，1991
實物尺寸的花販攤（鋼、木頭、防水布、
燈光、固定物、花桶）與鮮花
239 x 183 x 122
世界藝術基金會、愛爾蘭現代美術館收藏

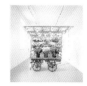

Costermonger Stall n°3, 1991
steel, wood, tarpaulin, lighting,
fixtures, plastic buckets and fresh
flowers
239 x 183 x 122
Collection Irish Museum of Modern Art,
on loan from the Weltkunst Foundation

安雅・葛拉契歐 **Anya GALLACCIO**

52

追尋彩虹，1998
尺寸視場地而定
玻璃、光線
藝術家自藏

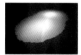

Chasing Rainbows, 1998
glass, light
Dimensions variable
The Artist

麥特・克里修 **Mat COLLISHAW**

53

無題（冷凍鳥），1994
雙色照片、透明壓克力、燈泡、鋼材
28 X 20.4 cm each
諾丁漢古堡美術館與畫廊收藏

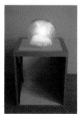

Untitled (Frozen Birds), 1994
2 colour photographs, perspex,
lightbulbs, steel
28 X 20.4 cm each
Nottingham City Museums and
Galleries, The Castle Museum and Art
Gallery

54

煙與鏡子，1996
玻璃罩、合成樹脂底座、影像投射、聲音
80 x 44 x 48 cm
湯瑪斯・丹與艾佛・布拉卡收藏

Smoke' n Mirrors, 1996
glass dome, formica plinth, video
projection, sound
80 x 44 x 48 cm
Collection Thomas Dane and Ivor Braka

道格拉斯・葛登 **Douglas GORDON**

55

一秒十尺，1994
錄影裝置，第三版
螢幕 228 × 305
竿子 290 - 374
英國文化協會收藏

10 ms-1 ,1994
video installation, edition of 3
screen 228 x 305
pole 290-374
The British Council

席奧芳・哈帕思卡 **Siobhán HAPASKA**

56

嚮往，1997
玻璃纖維、塑膠表面與藍色 LED（2/3
版）
145 x 220 x 50
都柏林柯爾林畫廊提供

Hanker, 1997
fibreglass, polyester gel coat and blue
LED (edition 2/3)
145 x 220 x 50
Courtesy Kerlin Gallery, Dublin

57

逸出，1997
美國滾草、黃銅、鋁、電子裝置（1/2 版）
67 x 500 x 70
都柏林柯爾林畫廊提供

Stray, 1997
American tumbleweed, copper,
aluminium, electronic
(edition 1/2)
67 x 500 x 70
Courtesy Kerlin Gallery, Dublin

58

審判者，1997
蠟、合成毛髮、絲、油彩、椅子、合成音
效
125 x 106 x 89
藝術家與都柏林柯爾林畫廊提供

The Inquisitor, 1997
wax, synthetic hair, silk, oil paint, chair,
audio components
125 x 106 x 89
Collection of the Artist, Courtesy Kerlin
Gallery, Dublin

莎拉・盧卡斯 **Sarah LUCAS**

59

自畫像，1990-1998，1999
12 幅水彩紙虹印，1/150 版
英國文化協會收藏

Self-portraits 1990-1998 , 1999
12 Iris prints on watercolour paper
number 1 of an edition of 150
The British Council

a.吃香蕉，1990
 Eating a banana
 60 x 80

b. 神聖的，1991
 Divine
 60 x 80

c. 自畫像與茶杯，1993
 Self-portrait with mug of tea
 80 x 60

d. 自畫像與燈籠褲，1994
 Self-portrait with knickers
 80 x 60

e. 自畫像與煎蛋，1996
 Self-portrait with fried eggs
 80 x 60

f. 人類馬桶（二），1996
 Human Toilet II
 80 X 60

g. 以火攻火，1996
 Fighting fire with fire
 80 x 60

h. 自畫像與頭顱，1997
 Self-portrait with skull
 80 x 60

i. 得到一條鮮魚 第三號，1997
 Got a Salmon on #3
 80 x 60

j. 夏季，1998
 Summer
 80 x 60

k. 抽煙，1998
 Smoking
 80 x 60

l. 再訪人類馬桶，1998
 Human toilet revisited
 80 x 60

60

去他的命運，2000
紅色沙發床、日光燈、盒子、燈泡
95 x 165 x 197
©莎拉・盧卡斯，倫敦莎蒂・柯爾斯 HQ
提供

Fuck Destiny, 2000
red sofa bed, fluorescent lamp, box,
light bulbs
95 x 165 x 197
© Sarah Lucas, Courtesy Sadie Coles
HQ, London

理察・威爾森 **Richard WILSON**

61

皇后飯店 921 房（局部）2001
水綜合媒材
305 x 550 x 366
藝術家自藏　本館委任藝術家創作

921 Empress Hotel, (detail) 2001
Mixed media
305 x 550 x 366
The Artist, commissioned by the Taipei
Fine Arts Museum

參考書目
Further reading

Kynaston McShine: *Primary Structures: Younger American and British Sculptors*, Jewish Museum, New York, 1966

Harold Szeeman, Scott Burton, Gregoire Muller, Tomaso Trini: *Live in Your Head - When Attitudes Become Form: Works-Concepts-Processes-Situations-Information*, Berne Kunsthalle, Museum Haus Lange, Krefield, 1969

British Sculpture in the Twentieth Century, edited by Sandy Nairne and Nicholas Serota, Whitechapel Art Gallery, London, 1981

A Quiet Revolution: British Sculpture Since 1965, edited by Terry A. Neff, Museum of Contemporary Art, Chicago / San Francisco Museum of Modern Art; published by Thames and Hudson Limited, 1987

Lewis Biggs, Juan Munoz: *Entre el Objeto y la Imagen: Escultura britanica contemporanea*, Ministerio de Cultura, Direccion General de Bellas Artes y Archivos, Madrid and the British Council, 1986

Martin Kunz, Charles Harrison, Lynne Cooke, Iain Chambers: *Starlit Waters: British Sculpture and International Art 1968-1988*, Tate Gallery, Liverpool, 1988

Catherine Grenier, Francoise Cohen, Lynne Cooke: *Britannica. 30 Ans de Sculpture*, Musee des Beaux Arts Andre Malraux, Le Havre, 1988

Jon Thompson, William Tucker, Yehuda Safran: *Gravity & Grace: The Changing Condition of Sculpture 1965-75*, The South Bank Centre, London, 1993

Keith Patrick: *Contemporary British Sculpture: From Henry Moore to the 90s*, Auditorio de Galicia, Santiago de Compostela / Fundacao de Seralves, Oporto, 1995

Un Siècle de Sculpture Anglaise, edited by Francoise Bonnefoy, editions du Jeu de Paume / Reunion des musees nationaux, Paris, 1996

Michael Archer, Greg Hilty: *Material Culture: The Object in British Art of the 1980s and '90s*, South Bank Centre, London, 1997

Declan MacGonagle, Richard Cork, Penelope Curtis: *Breaking the Mould: British Art of the 1980s and 1990s*, Lund Humphries, London in association with the Irish Museum of Modern Art, 1997

Andrew Causey: *Sculpture Since 1945*, Oxford University Press, 1998

James Roberts, Hiroya Sugimura, Akio Obigane, Junichi Shioda: *Real/Life: New British Art*, Asahi Shimbun, 1998

攝影版權
Photographic Credits

courtesy Annely Juda Fine Art, London (1,2,3)

courtesy the Artist (4)

Margarida Ramacho (5)

Antonia Reeve (6)

© The Artist, all rights reserved DACS, photo: Charlie Meecham (7)

Arts Council Collection © The Artist (8, 24, 29, 35, 47)

Rodney Todd-White and Son (9, 10, 11)

© Tate, London 2000 (12, 22)

The British Council © the Artist (13, 23, 25, 42, 46)

Arts Council Collection © the Artists (14, 15, 16, 17)

courtesy the Artist and Anthony d'Offay Gallery, London (18, 19, 20, 21, 43, 44)

courtesy Lisson Gallery, London (26, 27, 36, 39, 40, 55)

Gareth Winters, London (28)

The Artist © (30, 31, 32, 33, 34)

Morten Thorkildsen, Oslo (37)

courtesy White Cube, London (38, 41, 48, 49)

Paragon Press, London © The Artist (45)

Collection of Simmons & Simmons (50)

Collection Irish Museum of Modern Art, on loan from The Weltkunst Foundation (51)

Shigeo Anzai (52)

Nottingham City Museums and Galleries; The Castle Museum and
Art Gallery (53)

courtesy Thomas Dane, London (54)

courtesy Kerlin Gallery, Dublin (56, 57, 58)

© Sarah Lucas, courtesy Sadie Coles HQ, London (59, 60)

＊根據作品清單號碼
＊ please refer to the no. of "list of work"

靜觀其變　英國現代雕塑展

FIELD DAY　Sculpture from Britain

展覽策劃: 張芳薇　理查‧瑞禮
展務助理: 佛德列克‧都麗薇

curated by CHANG Fangwei and Richard Riley
assisted by Frédérique Dolivet

發行人兼出版者	黃才郎
著作權人	台北市立美術館
總編輯	陳淑鈴
策劃執行編輯	張芳薇
編輯助理	許瑞容
翻譯	賴小秋 嚴玲娟 屈享平 涂景文
美術設計	馮建華 陳瓊瑜 林宗興
公關	胡慧如
展覽佈置	馮建華 賈台生 白寶南 盧秀瑛
場務協助	蘇乾金 林宜君 陳盈瑛
展覽登錄	全永慰
錄影機電燈光	何仲昌 陳昌平 張集翔 張裕政 陳燕山 范文芳 蔡鳳煌
總務	莊永煉
會計	許金兆 蔡妙緗
發行處	台北市立美術館
	台北市中山北路三段 181 號 電話：886-2-25957656 傳真：886-2-25944104
統一編號	14102936
印刷	沅立印刷股份有限公司
出版日期	中華民國九十年四月 初版

Director	HUANG Tsailang
Publisher	Taipei Fine Arts Museum
Chief Editor	CHEN Shuling
Executive Editor	CHANG Fangwei
Editorial Assistant	HSU Juijung
Translators	Autumn LAI, YEN Lingchuan, CHU Hsiangping, David J. TOMAN
Art Designer	FENG Chienhua, CHEN Chiungyu, LIN Tzung-Shing
Public Relations	HU Huiru
Exhibition Display	FENG Chienhua, CHIA Tai-shen, PAI Paonan, LU Hsiuying
Exhibitiob Staff	SU Chienchin, LIN Yichun, CHEN Yening
Registrar	CHUANG Yungwei
Video and Lighting	HO Chungchang, CHEN Changping, Steven CHANG, CHANG Yuchen, CHEN Yenshan, FAN Wenfang, Nasa TSAI
General Affairs	JUANG Yeongliann
Accountant	HSU Chingzau, TSAI Miaohsi
Publisher	Taipei Fine Arts Museum
	181,Chung Shan N.Road,Sec 3 Taipei,Taiwan,R.O.C.
	Tel : 886-2-25957656
	Fax : 886-2-25944104
Printer	Yuanli Color Printing Co., Ltd.
Publication Date	April 2001, First Ed.

ISBN 957-02-8172-3 (平裝)

國家圖書館出版品預行編目資料

靜觀其變 英國現代雕塑展 = FIELD DAY
Sculpture from Britain / 陳淑鈴總編輯.
-初版. --臺北市： 北市美術館，民 90
面：　公分

參考書目：面
ISBN 957-02-8172-3（平裝 ）
1. 雕塑．英國．作品集
930　　　　　　　　　90004762